How to Paint
LANDSCAPES
ALWYN CRAWSHAW

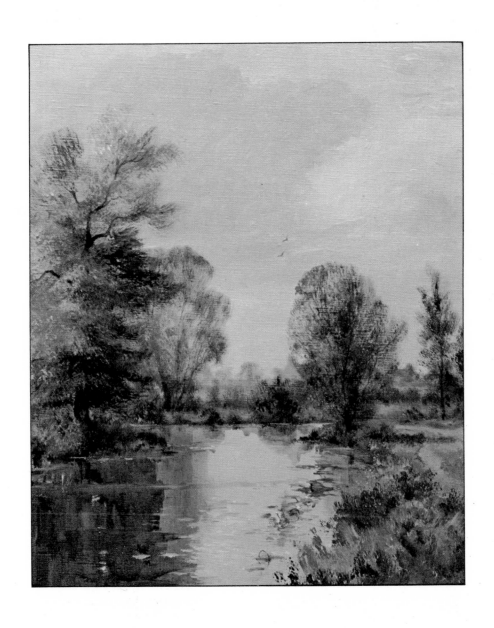

HPBooks

Published in the United States by
HPBooks
P.O. Box 5367
Tucson, AZ 85703
602/888-2150

Publishers: Bill and Helen Fisher
Executive Editor: Rick Bailey
Editorial Director: Randy Summerlin
Editor: Judith Wesley Allen
Art Director: Don Burton
Book Design: Leslie Sinclair

First Published 1981 by
Collins Publishers, Glasgow and London

ISBN 0-89586-267-0
Library of Congress Catalog Card Number: 83-80903

Notice: The information in this book is true and complete to the best of our knowledge. All recommendations are made without guarantees on the part of the author or HPBooks. The author and HPBooks disclaim all liability incurred in connection with the use of this information.

CONTENTS

Portrait of an Artist—Alwyn Crawshaw ... 4

Painting Landscapes 6

Equipment 12

Basic Drawing and Perspective 16

Start Painting 18

Painting the Sky 20

Painting Trees 22

Painting Water 24

Painting Ground and Snow 26

Painting from Memory 28

Painting from Photographs 30

Pencil Sketching Outdoors 32

Pencil Sketching on Location 34

Painting in Acrylics from a Pencil Sketch .. 38

Watercolor Sketching Outdoors 42

Painting a Watercolor on Location 44

Painting in Acrylics
from a Watercolor Sketch 48

Painting Mountains in Oils 52

Painting the Sky in Oils 56

Painting Snow in Acrylics 58

Painting a Meadow in Pastels 60

Painting Farm Buildings in Watercolors ... 62

Points to Remember 64

Index 64

Portrait of an Artist— Alwyn Crawshaw

Alwyn Crawshaw was born in 1934 at Mirfield, Yorkshire, England. During his earlier years, he studied watercolor and oil painting. More recently, he has worked in acrylics and pastels.

Crawshaw is a successful painter, author and lecturer. He is included in *Who's Who in Art* and *Who's Who in the World*. Crawshaw has other books in HPBooks' *How To Paint* series, including *How to Paint with Watercolors, How to Paint with Acrylics* and *How to Paint Boats and Harbors*.

Crawshaw paints realistic subjects. These include many English landscape scenes. His paintings are compared with the works of John Constable, the famous English landscape artist. Most of Crawshaw's landscapes have a distinctive trademark, usually elm trees or working horses.

Crawshaw's work became popular after his painting, *Wet and Windy*, was included in the top 10

Gathering Mist, 36x24". Print from an original acrylic painting by the author. Illustrated by permission of Felix Rosenstiel's family.

prints of the Fine Art Trade Guild in 1975.

Another well-known painting was completed during Queen Elizabeth's Jubilee Year in 1977. Crawshaw wanted to record an aspect of Britain's heritage. He completed *The Silver Jubilee Fleet Review 1977* after much research and many hours working on location.

Crawshaw has been a frequent guest on Britain's radio and television talk shows. He demonstrates his techniques to many art societies throughout Great Britain. His paintings are on exhibit throughout the world.

Crawshaw has exhibited in one-man shows at the art gallery of Harrods department store in London. Another one-man show was opened by the Duchess of Westminster, who now has a Crawshaw painting in her collection.

One-man exhibitions of his work draw an enthusiastic audience. There is an air of reality about his work.

According to Crawshaw, two attributes are necessary for artistic success: *dedication* and *a sense of humor*. The need for the first is self-evident. The second "helps you out of many a crisis."

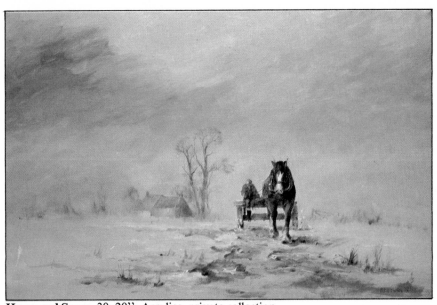

Horse and Snow, 30x20". Acrylics, private collection.

Painting Landscapes

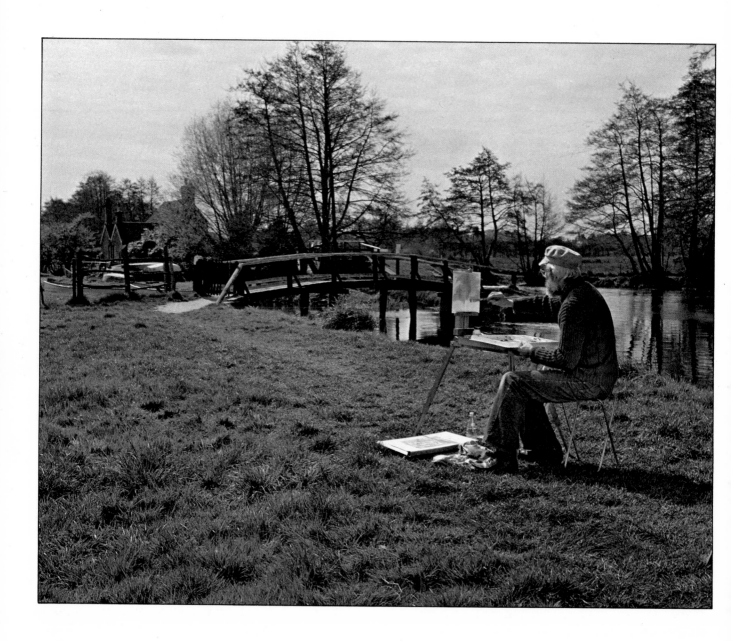

Landscapes are an endless source of subjects for painting. You can stand in one spot in the country and see a different picture in each direction. You can paint the sunrise, sunset, daylight, dark, sun, wind, rain, mist and so on. Then add the four seasons. Just one viewpoint provides dozens of pictures during the year.

Plentiful subjects are not the landscape painter's only advantage. Enjoyment of the outdoors is another advantage. All of us want to get out sometimes. We yearn to feel close to nature. We want to see a vast landscape with wind-swept clouds, or a tree fallen across an abandoned road.

All our senses, not just our vision, are with us

You can work outdoors in any medium without a lot of equipment. I am painting in acrylics, opposite page, sketching in pencil, below, and working in pastels, below right.

outdoors. Our sense of touch allows us to feel the wind and the sun's warmth. We can hear the sounds of the countryside: birds singing, water running and wind blowing through trees. Above all, our sense of smell inspires us to paint landscapes: the sweet smell of summer grass, the dank smell of wet autumn leaves, the damp smell of a dusty road after a summer rain.

You can understand why artists throughout history have painted landscapes. The artist can hardly resist it. He has subjects to last a lifetime in different times of day and changing seasonal moods. His senses of sight, touch, hearing and smell are stimulated constantly.

When you are painting, your senses are invaluable to your work. Your vision forms the picture. Touch, hearing and smell help you keep the painting's mood or atmosphere. If you feel the sun's warmth, you are reminded you are painting a warm picture. If you hear birds singing, you are reminded the landscape is alive and tranquil. The smell of a warm summer day completes your awareness of what you are painting.

Try to imagine yourself outdoors painting a view you can see, but unable to feel the sun, hear the birds or smell the summer grass. Your painting would have no feeling or atmosphere. A landscape painting without these is a "dead" picture.

Watercolor is an ideal medium for outdoor work. It is probably the most convenient medium for the beginner.

Oil is a traditional medium for outdoor painting that everyone can enjoy.

Painting landscapes indoors from outdoor sketches is a natural way to paint. Most of the old masters worked outside on small sketches to use for information and inspiration in larger indoor paintings. One advantage of painting indoors is more time to consider your painting's progress and change parts of it you feel necessary.

What do the words *sketch* and *sketching* mean? Both are commonly used in painting. I believe there are four types of sketches:

Enjoyment Sketch—A drawing or painting done on location for enjoyment.

Information Sketch—A drawing or painting done to collect information and details for use later at home.

Atmosphere Sketch—A drawing or painting done to capture atmosphere and mood for use later in the finished painting. It is used for atmosphere and mood information, or for inspiration for an indoor landscape painting.

Specific Sketch—A drawing or painting of a *specific place* to gather as much information—details and atmosphere—as possible. It conveys the mood or atmosphere of the occasion. The sketch is the basis for a finished studio painting. The specific sketch is a combination of information and atmosphere sketches.

All sketches, whether drawings or paintings, can be *finished* works. Some artists' sketches are preferred to their finished paintings. We will cover sketching in depth beginning on page 32.

The sketch on the opposite page is an enjoyment pencil sketch drawn in 30 seconds from a train window while traveling at high speed. An atmosphere sketch and an information sketch are shown on page 32.

Mother Nature is the main teacher for all landscape artists. Always remember this. Go out and paint the countryside whenever you can. Observe all you can. When you are traveling, look at what you see as if you will paint it. When I was in art school, I was taught to observe and translate what I saw into a painting in my mind. I still do this. I can be out with my family, talking about anything other than painting. Suddenly I will stop and say excitedly, "Look at that, isn't it fantastic? It would make a perfect watercolor," or acrylic painting, or whatever suits the scene.

Carry a sketchbook with you when you go outdoors. If you have time, draw. Use every opportunity. If you want to sketch, you will find opportunities. If you don't, pressure yourself and make time.

I wrote this book to teach you to paint landscapes in several media. I use watercolors, oils, acrylics and pastels. This shows you the depth and variety of expression in landscape painting. If you want to learn more about these media, read the other titles in HPBooks' series, including *How to Paint with Acrylics*

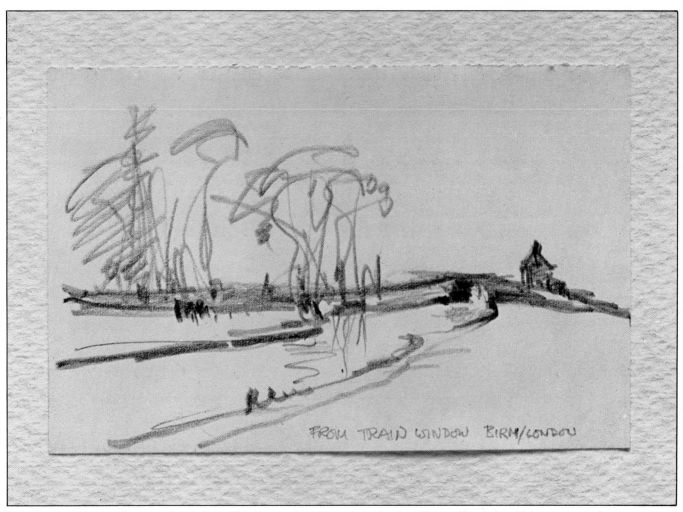

This sketch was drawn from a train window. This is reproduced actual size to show the small scale in which you can work.

and *How to Paint with Watercolors* by Alwyn Crawshaw, *How to Paint with Oils* by Peter John Garrard and *How to Paint with Pastels* by John Blockley.

I choose a particular medium for each exercise because it suits the subject.

When you are painting outdoors, don't become obsessed with your work. You will miss the joy of painting outside. *Enjoy your painting.*

There will be times when nothing goes right. You will blame everything from your paintbrush to the weather. This happens to all of us.

Your work is spontaneous when you paint from nature. You will learn something, even in brief encounters. Never throw away a poor sketch or painting. Every line tells a story. Learn from your successes and mistakes.

I decided to paint the 200th Derby at Epsom, Surrey. This sketching day provides a good example of a *specific sketch.* It shows the difference in use of the word sketch. The Derby sketches were planned

and premeditated, in contrast to the 30-second pencil sketch above.

I had never been to a horse race before. My initiation was the Derby at Epsom. The news media suggested half a million people might attend.

Paintings must be planned. I started planning this one on Saturday before the Wednesday race. A friend took me to the racetrack so I could become familiar with it and decide where to paint.

It was a pleasant and warm afternoon. I was amazed at the activity four days before the race. The fairground was bustling with people. I would have loved to visit all the sights, but I didn't have time. The important thing was to find the right painting spot.

We walked through the tunnel under the track and out to the middle of the course. I walked up the hill to look at the view. I stopped twice to do an information sketch in pencil, 16x11'', of the stand area. This area would be partly obscured by people

The photograph I took of the scene.

that day. When we reached the hilltop, I knew what I would paint.

The view was vast. I could see miles into the country. I could get most of the track's stand and finish line in the picture. I decided earlier to work on a 60x30'' canvas if I could get that type of view. My mind was made up. I sat down and did the pencil sketch at top right on the opposite page. I looked forward to the race on Wednesday.

The race was to start at 3:25 p.m. Because of the expected crowds, I decided to get there about 8 a.m.

On race day, my senses soaked up the atmosphere. I used my camera to gather information. Then it was time to get on with the sketching from my prearranged vantage point.

Before I sketched from the hill, I looked at the scene first for half an hour to get accustomed to it.

I drew the picture with an HB pencil, and then went into a full watercolor sketch, 21x14-1/2''. The scene expanded rapidly as I worked. Cars and buses converged on the site.

I worked on the main parts of the painting for two hours without a break. Then I added more to it over the next hour and a half. Because of my sketching the previous Saturday, I was comfortable with the scene. I felt I had been at the race before. This helped the drawing flow so I could concentrate on color and atmosphere. The finished watercolor sketch is in the middle of the opposite page.

It was an exhilarating day. I was exhausted when I sat down at home that evening. I had everything in my pencil sketches, watercolor, memory and photographs to paint the Derby in the studio. I also painted a smaller picture, 24x16'', of the horses approaching Tattenham Corner in the race.

This type of outdoor sketching is different from sketching an afternoon scene in the country. Organizing something like this once or twice a year fosters self-discipline and planning. Both are important for a landscape artist. If you approach it the right way, you will enjoy it.

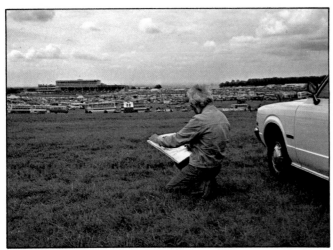

Sketching just before the horse race.

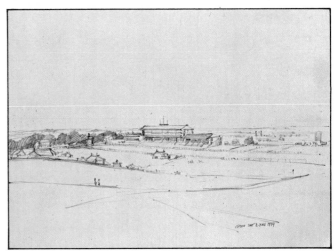

Pencil sketch, 16x11".

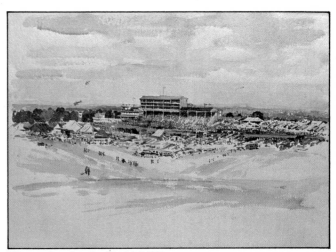

Watercolor sketch, 21x14-1/2".

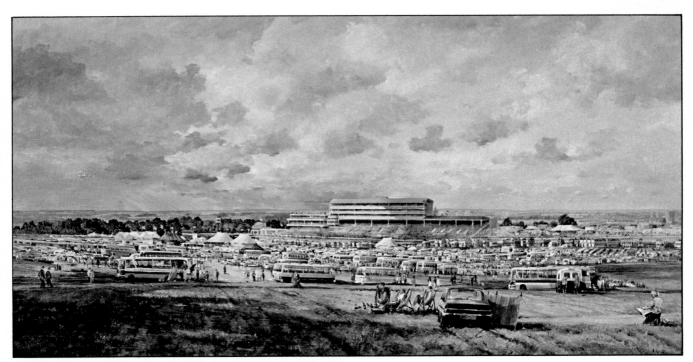

The 200th Epsom Derby Day, 60x30". Acrylics, private collection.

Equipment

Equipment for painting landscapes is the same as for any other subject. You can have a room full of equipment or just the essentials. The choice is yours.

Buy the best materials you can afford. You will work easier and have better results. The photograph opposite shows materials for acrylics, oils, pastels and watercolors. The basic requirements for each medium are shown on page 15. These are the materials I work with throughout this book.

MEDIA

Watercolors—You can buy watercolors in tubes, half-pans or whole pans. I do not recommend tubes for beginners. It is difficult to control the amount of paint on the brush. You can buy pans individually or in boxed selections. The colors I use are Payne's gray, burnt umber, Hooker's green No. 1, ultramarine blue, alizarin crimson, yellow ochre, cerulean blue, burnt sienna, cadmium red, raw umber, raw sienna and cadmium yellow pale.

Acrylics—There are several types of acrylics, but I prefer two. One's consistency is similar to oil paint and is ideal for palette knife work. The other is thinner and better with a brush. It takes longer to dry than the first. The thinner type is my basic paint. You can use texture paste to build up a heavy impasto. The acrylic colors I use are cerulean blue, bright green, burnt umber, raw umber, cadmium yellow, cadmium red, crimson, ultramarine, raw sienna and white.

Oils—The oils I use are cobalt blue, cadmium red, cadmium yellow, ultramarine blue, viridian green, alizarin crimson, burnt umber, yellow ochre and titanium white.

Pastels—There are many pastel colors. Each is available in several tints. It is best to start with a box of 12 or 36 soft pastels for landscape. When you get used to the medium, you can buy other tints, colors or pastel refills.

BRUSHES

An artist's most important tool is his brush or painting knife. The brush achieves the painted effects. Whether your effect is bold or delicate, your brush dictates it.

I want to emphasize the importance of buying the best brushes you can afford. The following beginners' basic equipment sets are those I suggest you start with. The brushes pictured on page 14 show the different shapes, types of hair and sizes. All are actual size. The brushes on the left are round sable brushes—size No. 00 to size No. 12. Some brush series have additional sizes, such as Nos. 9, 11 and 14.

A Paint rag
B Acrylic palette, paints, palette knives
C Brush case and brushes
D Acrylic primer, mediums, texture paste
E Brushes and jar
F Oil-painting varnish, turpentine, drying and impasto mediums, linseed oil, charcoal, tube paints, mixing knife
G Paintbox
H Stretched canvas
I Canvas board
J Water containers
K Watercolor boxes, brushes, sponge, pen and India ink, tissue paper
L Tube watercolors, mixing palette, brushes, pencils, kneaded eraser, watercolor paper, watercolor sketchbook, white designers' gouache
M Pastel papers, sketchbook, dusting brush
N Soft pastels
O Varnish, clear fixative, workable fixative

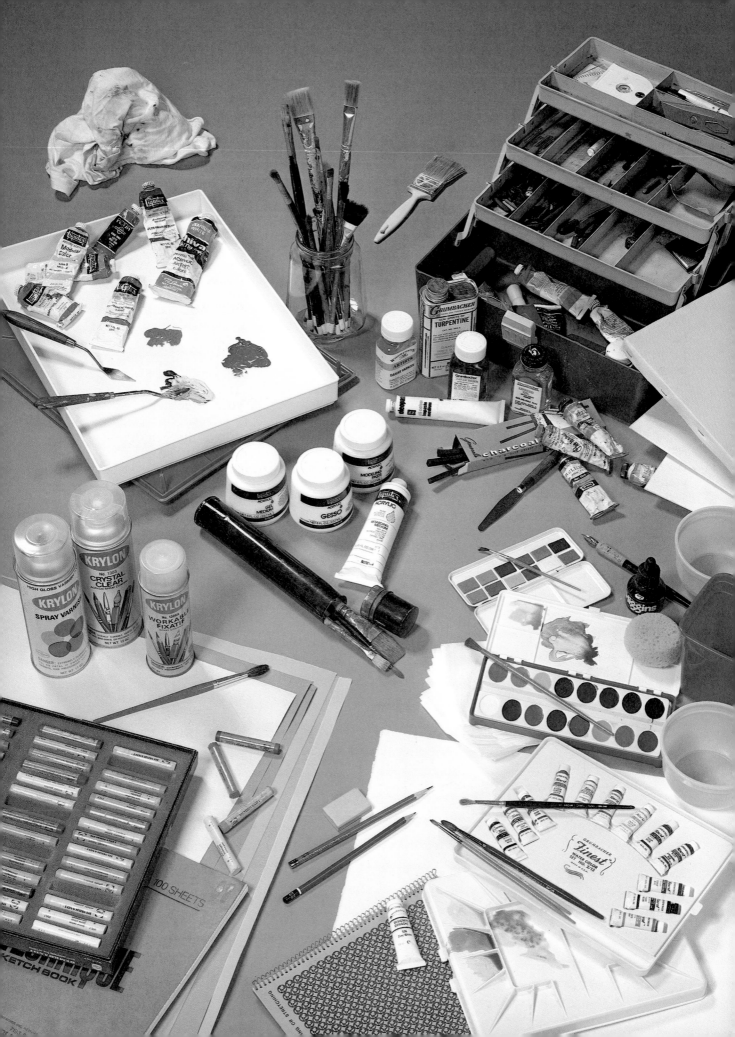

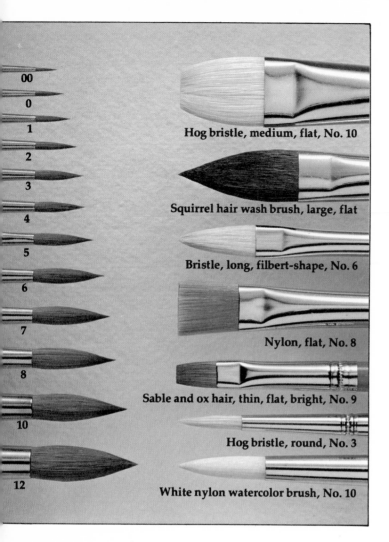

00
0
1
2
3
4
5
6
7
8
10
12

Hog bristle, medium, flat, No. 10

Squirrel hair wash brush, large, flat

Bristle, long, filbert-shape, No. 6

Nylon, flat, No. 8

Sable and ox hair, thin, flat, bright, No. 9

Hog bristle, round, No. 3

White nylon watercolor brush, No. 10

Take care of your brushes. This doesn't mean you should keep them in a glass case. You should work them hard. A good brush can take hard work.

My nylon tree brushes on page 48 look neglected. Those brushes are for painting feathery branches on trees. They have been cared for and used almost every day for several years. That's a lot of hard work for any brush. If they had not been of the finest quality to start with—and if I had not taken care of them—they would have been ruined years ago.

BASIC EQUIPMENT SETS

Watercolors—You can start with two brushes, a No. 10 round and a No. 6 round. Quality depends on price, but they should be sable. You need a paint-box to hold 12 whole or 12 half-pans of color. The one shown on the opposite page holds whole pans. You also need HB and 2B pencils, a kneaded eraser, a drawing board with watercolor paper or a watercolor sketching pad, blotting paper, a sponge and a water container. I suggest you also carry a tube of white paint. I use *designer's gouache*—which is opaque watercolor.

Acrylics—I use four nylon brushes and a sable brush for the exercises in this book. They are No. 2, No. 4, No. 6 and No. 12 nylon brushes and a No. 6 round sable brush. A No. 1 sable is used for very thin line work. I recommend a palette that will keep your paint moist. You can use a gel retarder to keep the paint wet on the canvas longer. Use paper, board or canvas as a painting surface. An HB pencil, kneaded eraser, paint rag and water container complete this sketching set.

Oils—You need a box for your paints. The one shown opposite holds everything except the rag. You can rest the box on your knees as an easel. This box is available empty or as a kit with materials. You can also use an old suitcase. The bristle brushes are Nos. 4, 6, 8 and 10, and the sable is a No. 6 round. You need a palette knife, purified linseed oil, turpentine, gel medium to speed drying of the paint, canvas board, palette, dipper cups for linseed oil and turpentine, an HB pencil, a kneaded eraser and a rag.

Pastels—Use either of the two boxes I described on page 12. The one pictured opposite contains 12 colors for landscape painting. You need paper or a pastel sketching pad with a selection of colored sheets. You also need fixative, a bristle brush to rub out areas of pastel, a kneaded eraser, an HB or 2B pencil and a rag to clean your hands.

The subject of paper is too broad to discuss here. Ask someone in an art supply store for help.

Brushes, paints, paper, the stool you sit on and other materials are a personal choice. Choices emerge through experience and experimentation.

All the materials shown here are of the best quality. You can buy them in any good art supply store.

BEGINNERS' BASIC EQUIPMENT SETS

Watercolors

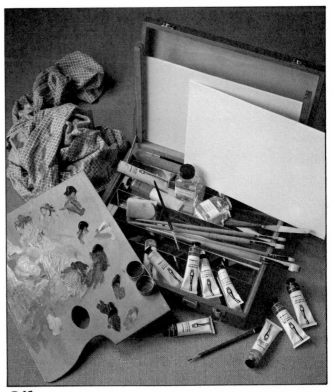

Oils

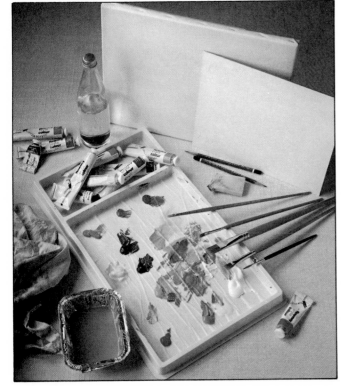

Acrylics

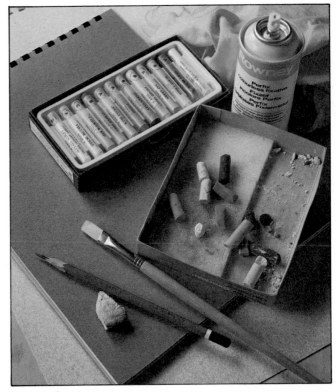

Pastels

15

Basic Drawing and Perspective

A drawing is the groundwork for a painting. We will practice drawing in *perspective* before you start painting.

Some artists can paint a picture but can't draw in perspective, a technique that gives objects the appearance of having three-dimensional form and shape. A painting is made up of colors, shapes and tones. If you want details in a picture, you need to be able to draw. This comes only with practice.

Through the ages, artists have looked for ways to simplify drawing. Drawing aids have been invented. But it is simpler to learn the basics of perspective drawing.

Become familiar with the terms *horizon, eye level* and *vanishing point.* Let's see how to use them in drawing.

When you look out to sea, the horizon is always at eye level, even if you climb a cliff or lie on the sand. *The horizon and the eye level are the same.* If you are in a room, there is no horizon. But you have an eye level. To find it, hold your pencil horizontally in front of your eyes at arm's length. Your eye level is where the pencil crosses the opposite wall.

If two parallel lines on the ground were extended to the horizon, they would appear to come together at the *vanishing point.* This is why railroad lines appear to get closer together until they meet in the distance. They have met at the vanishing point.

Look at the illustration below. I have drawn three red squares. In drawing A, I have drawn a line through the middle of the square as the eye level (E.L.). At the left end of the eye level, I have made a mark for the vanishing point (V.P.). This gives me the sides, bottom and top of the box. To create the other end of the box, I have drawn a square parallel with the front of the box and within the vanishing point guidelines. The result is a "transparent box" drawn in perspective. I call it the *normal view.*

The same box is drawn in drawings B and C, but the eye level has been moved. In drawing B, the eye level is low, *a worm's-eye-view.* In drawing C, the eye level is high, *a bird's-eye-view.* Eye level is important. It is the first element you must locate when you sketch. When you fix your eye level on paper, everything can fall into place.

The illustration at top right shows the box from

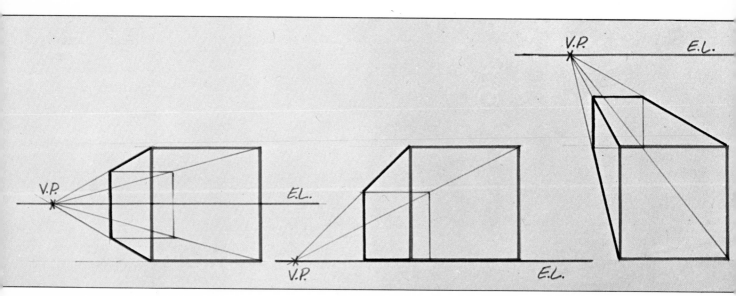

A. Normal view **B. Worm's-eye-view** **C. Bird's-eye-view**

the bird's-eye-view. The box is painted to look solid. Try this simple exercise. It is one of the most important exercises you will ever practice. You are creating the illusion of *depth, dimension* and *perspective* on a flat surface—a three-dimensional object. If you have never painted before and are uncertain about painting within a shape, read the next section and come back to this one later.

One reason the box at top right looks three-dimensional is because the light against dark shows *form*. Light against dark enables us to see objects and understand their form. Imagine a blue box painted on a background of the same blue. If there is no light against dark, it looks like figure A at right. Add light and shade, and it looks like figure B. Be conscious of light against dark when you paint.

You can draw clouds in perspective in a simplified way as the boxes were drawn. The sketch at bottom right illustrates this method. Seeing the perspective of natural objects helps you draw with conviction.

Look at the sky through half-closed eyes. The lights and darks of the clouds are exaggerated, and the middle tones aren't seen. You have strong, contrasting shapes with which to work.

Look at a landscape through half-closed eyes next time you are out sketching. You will see well-defined shapes in the landscape to make your drawing easier. It helps to simplify your work at first.

The first steps in landscape painting must be thought out carefully. Beginners should not be too ambitious. Spirit and self-confidence are fine. Not reaching your goal—if it's too high—can ruin your confidence and set you back. If you try a simple subject and complete it to your satisfaction, the result boosts your confidence. Have spirit and determination, but remember, "Don't try to run before you can walk."

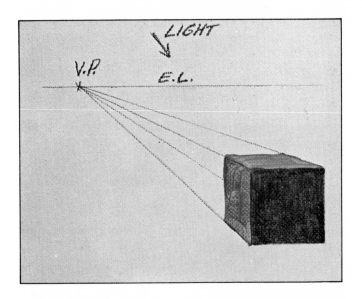

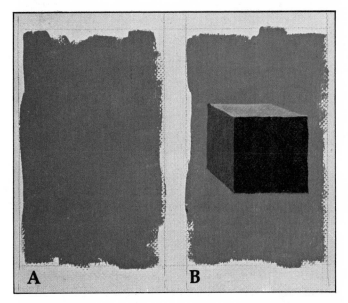

A B

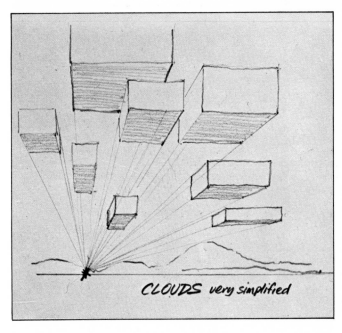

CLOUDS very simplified

Start Painting

EXPERIMENTING WITH PAINT

At last you can paint. If you have chosen your medium, you can proceed. If you have not decided on a medium, now you can make a choice. For beginners, I suggest watercolors.

Most of us used a water-based paint as children. We dipped a brush in water and mixed it into paint. This is a basic form of watercolor painting. I suggest you start with this medium because it will be more familiar than anything else. It is the most convenient medium for the beginner.

Beginning painters often find it difficult to put paint on paper. We are self-conscious when we haven't tried something before. Observers are no help with their criticisms! Don't let this deter you.

The first step into painting will be with colors. The hundreds of colors around us can overwhelm a novice. But there are only three basic colors: red, yellow and blue. These are called the *primary colors*. They are shown at the top of the next page. All other colors are a combination of these three. We can use different reds, yellows and blues to re-create nature's colors in painting. Two samples of each primary color are shown.

Get some paper, and experiment with paint. See how the paint and brush feel. Add more water, use less water. Try anything you like to become familiar with the medium. You will end with a strange-looking, colored piece of paper—but you will understand paint and its application better. No matter which medium you choose, play with the paint before mixing colors. My doodles in watercolors and oils are at right.

As you gain confidence, you will find the next stage exciting.

MIXING COLORS

You must practice mixing paints to learn how various colors are obtained.

On the opposite page, I mixed primary colors to show you what happens. Cadmium yellow mixed with cadmium red makes orange. To make orange look more yellow, add more yellow than red—and vice versa to make it more red. Add white to make orange lighter.

Cadmium yellow mixed with ultramarine makes green. If you add white, you get a light green.

My lists of paint colors on page 12 do not include black. Some artists use black and others don't. I don't because I think black is a "dead" color. It is too flat. I mix blacks from the primary colors, as shown in the third mix on the opposite page. It may

seem difficult to get really dark colors. If you get frustrated and want to use black, use it sparingly.

Now, instead of playing with paint, practice mixing colors. Mix these on your palette with a brush. Dab the paint on paper or canvas. Don't worry about shapes—just colors. Experimentation and practice are essential. It's a helpful exercise to select an object and try to duplicate its color by mixing paint.

Because there are only three basic colors, the amount of each color plays the biggest part in mixing a color.

To mix a more yellow-green than the one shown, you must experiment on your palette. Work in more yellow until you have the color you want. Mixing colors is a lesson you must practice often. I still do.

A color wheel is a good aid to mixing. One is shown at right.

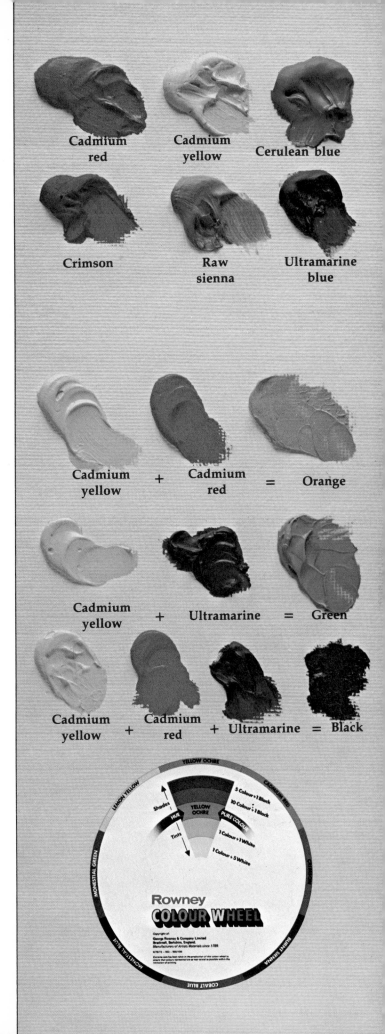

Cadmium red

Cadmium yellow

Cerulean blue

Crimson

Raw sienna

Ultramarine blue

Cadmium yellow + Cadmium red = Orange

Cadmium yellow + Ultramarine = Green

Cadmium yellow + Cadmium red + Ultramarine = Black

Painting the Sky

When you have practiced mixing colors, you are ready for simple exercises. Don't put many details in them. Copy my exercises from the book. You will then be familiar with the subject when you paint on location. It is important that you be familiar with your brushes, paints, color mixing and subject matter. The more familiar you are with your medium and subject, the more confidence you have. The more confident you are, the better your work.

These exercises cover the four main ingredients of landscapes: sky, trees, water, ground and snow. General notes apply to each subject and adapt to any medium. If I paint an exercise in watercolors and you are working in acrylics or pastels, then try it with your medium. The object of these lessons is to practice and learn.

I think sky is the most important ingredient in a landscape, no matter what the medium. The sky conveys the type of day, whether sunny, cold, windy or rainy. Even seen from indoors, the sky indicates what the weather is like. The sky's mood envelopes the landscape. If you capture this mood in painting the sky, then the mood follows throughout the painting.

Our senses help us keep the painting's mood alive. When you paint the sky, you are constantly reminded of the type day you are painting. If you paint a sky with feeling and atmosphere, you can paint successfully. If your sky has no atmosphere or feeling, the landscape will not be your best work.

You may be confused when you paint skies while outdoors. The clouds will not stop for you! Clouds in the distance will appear to move slower than those above you. This allows more time to paint them. You must paint the sky as it moves.

Start with pencil sketches—enjoyment, information and atmosphere sketches as described on page 8. Keep a sketchbook for skies only. It will become an important reference for you. Use a 2B or 3B pencil and a kneaded eraser to rub out highlights.

The secret of drawing moving clouds as they move is to watch the *pattern* of movement. Observe which banks of clouds are moving behind others, which are moving fastest and so on. Half-close your eyes and see the shapes in a simplified light-and-dark pattern. When you have the *feel* of the sky and its movement, wait for an interesting cloud formation. Look hard at it, hold your breath and off you go!

Start in the middle of the paper so you can maneuver in any direction. Roughly draw the cloud shapes. Shade in the tonal areas broadly. Depending on the speed of the clouds and your sketching speed, the formation you started with will change. If you have observed the pattern of cloud movement, you can adjust.

When you have started your sky formation, do not alter it to look like the changed sky. It will change again and you will be left "in the clouds." If you must change because the sky has developed a more interesting mood, then start again on another

These two atmosphere sketches, both 8x6-1/2", are in pastels.

page. Don't do these sky studies any larger than 11x8''. You can sketch them as small as 5x4''.

When you have enough confidence working in pencil, try color.

Note the time of day, position of the sun, type of day and date on all your nature sketches—especially skies. This information will help you understand the sketch later.

You paint skies the same way you sketch them. Use few colors. If you spend too much time mixing colors, the sky moves on. Even with paint, work as small as 5x4''. Add parts of a landscape when you paint sky, even if only a low line of distant hills. This gives the sky depth and dimension. Pastel is a good medium for quick sky studies. The long edge of a pastel provides a quick and sensitive medium to cover large areas of color.

SIMPLE EXERCISES

The actual paintings for these exercises on landscape ingredients are twice the size reproduced here. They are shown in two or three stages so you can see how the sketches developed.

The exercise at top right is oil on canvas board. It depicts a windy day. Fast-moving clouds leave parts of the landscape in rain and others in brilliant sunshine. I used three colors and white to make it simple. Work with a No. 8 bristle brush throughout. Use less white where colors are darker. When you paint the rain in the distance, let the brushstrokes show the direction of movement. Paint over the horizon. When you paint the distant hills, paint *over* the bottom of the rain with horizontal brushstrokes. This painting exercise was done in one sitting. It was painted *wet on wet*—without waiting for the first coats to dry.

The watercolor at right is on 140-pound, cold-pressed watercolor paper. This paper suits my type of work. I use it for almost all my watercolor paintings. Don't draw this sky. Just start at the top with a No. 10 sable brush. Use plenty of water mixed with cerulean blue and alizarin crimson. Let the brushstrokes form the clouds. When the first stage is almost dry, add yellow ochre to the color in your palette. Paint the cloud shadows and distant clouds. Draw with the brush. Paint the landscape with ultramarine blue and cadmium yellow pale.

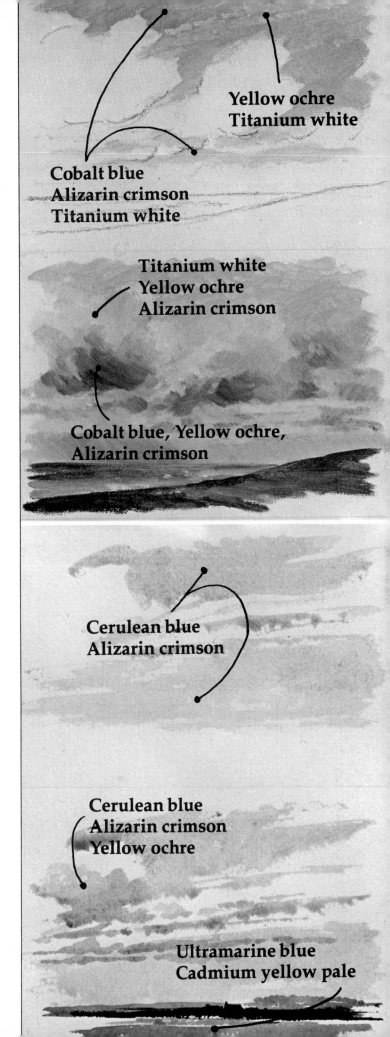

Yellow ochre
Titanium white

Cobalt blue
Alizarin crimson
Titanium white

Titanium white
Yellow ochre
Alizarin crimson

Cobalt blue, Yellow ochre,
Alizarin crimson

Cerulean blue
Alizarin crimson

Cerulean blue
Alizarin crimson
Yellow ochre

Ultramarine blue
Cadmium yellow pale

Painting Trees

The tree is nature's most valuable gift to the landscape artist in composing a picture. One tree can make a picture. Trees can break the horizon line. They attract the eye or lead the eye into the picture.

Go out and sketch only trees. Use a small sketchbook as I suggested for skies.

Learn to draw trees before you paint them. Find a good-looking barren tree if it's fall or winter. Draw a detailed information sketch of it. Work carefully at drawing every branch. You will learn about the tree—its form, growth pattern, size and so on. When you finish, your fingers and wrist will ache. You will realize how much you have learned about that one tree. You will feel attached to it.

Then use a sable brush and one color to do the same exercise with brushwork.

When the leaves come out on the trees, go out and sketch again. Use pencil first. Study the shape of the tree to get its character. You will find areas of sky showing through somewhere in the tree. You will always see some branches.

Never sketch a tree as a solid lump. If the tree is a mass of leaves—like a large chestnut—there will be light and shade in the foliage pattern. Half-close your eyes to pick out the different tones and shapes of the leaf masses. Shade them in with 3B pencil. Note the leaves that show dark or light silhouettes against the sky. These areas light up the tree and help identify its species.

Do your first sketch of a leafy tree from about 300 yards away. You will see only the broad shape and character of the tree. You won't be tempted to worry about details because you will not see them.

Then sketch progressively closer until you can do separate studies of branches and leaf areas in the tree. When you are close, you will have to half-close your eyes to pick out the shapes to draw.

When you are ready to paint, work broadly at first. Look for the large areas of leaves. Break those areas into smaller areas of shape, color and tone. Start again from about 300 yards. Work closer as you gain confidence. Don't put too many details in your middle-distance trees or they will "jump out" of your picture. Whether you use pencil, brush or pastel, draw the branches in the direction the tree grows. This helps create a sense of growth and reality.

To draw a tree, start at the trunk base and work upward. If the tree is mostly foliage, let the brushstrokes follow the direction of the fall of the leaves. Change to a smaller brush for small branches. It is tempting to use the big brush too long because you are in the swing of things. Change brushes!

Trees may look alike, but they are individual. Paint your trees as individual characters of nature.

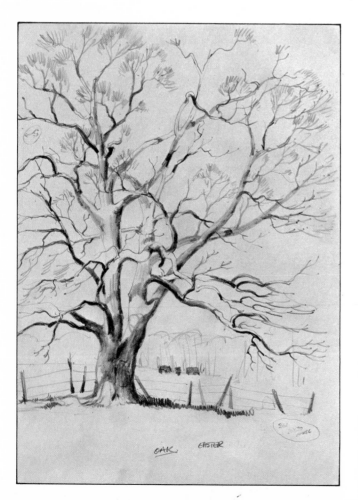

These information pencil sketches of trees were done in early spring before leaves came out.

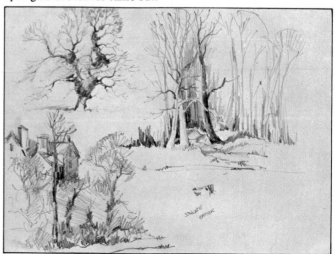

SIMPLE EXERCISES

The tree exercise at top right is a watercolor on 140-pound, cold-pressed watercolor paper. Draw the land and trees with an HB pencil. Don't put details in the foreground tree. Paint the sky with your No. 10 sable brush as you did in the sky exercise. Add cadmium yellow pale to the alizarin crimson near the horizon.

When the sky is dry, paint the distant trees with a No. 6 brush. While they are damp, paint the two smaller poplar trees and the field. Now paint the trunk and main branches of the foreground tree. Paint the foliage while it is wet. Use the long edge of your brush. Drag it sideways and down for a leaf effect. While still wet with the same color, paint shadows on the trunk.

Paint the ground with the same brush and the same color. Draw the fence and gate with the brush at the same time. It is impossible to copy my shapes exactly. Your brushstrokes will determine your foliage shapes.

The second exercise at right is a simple-but-effective tree study in pastel. I painted it with five pastel colors.

Draw simple tree shapes with HB pencil or pastel. Paint the background trees with indigo. Use the broad edge to shape treetops and the blunt edge to draw trunks. Drag the sky pastel, yellow ochre, into the distant trees. Paint the field with sap green, working slightly into the blue trees above. Use green-gray to paint the hedge of trees. Apply pressure to make these trees more dense.

Draw branches as you go. Don't try to copy mine. Paint the ground and fence with the same color. Add ivory black to the nearest trees to keep them in the foreground.

A painting like this should not take long because it is free and spontaneous. If you enjoyed it, do others and vary the composition and design. Use different papers and add pastel colors of your choice. You will finish with some nice paintings and a lot more experience.

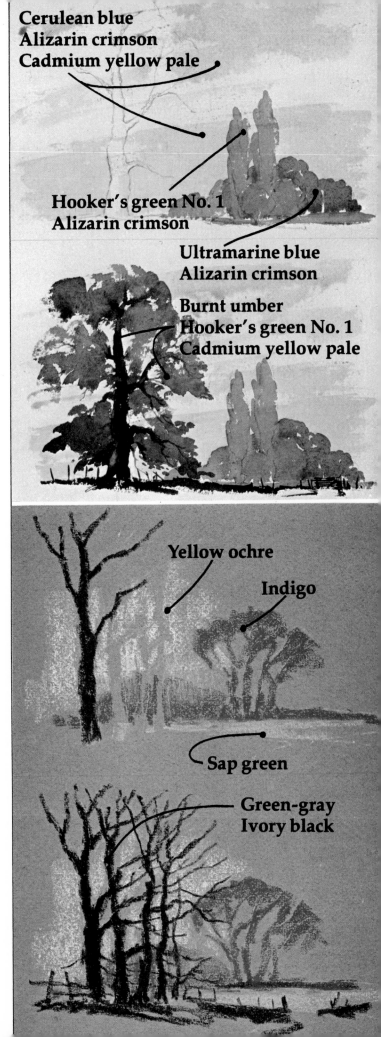

Cerulean blue
Alizarin crimson
Cadmium yellow pale

Hooker's green No. 1
Alizarin crimson

Ultramarine blue
Alizarin crimson

Burnt umber
Hooker's green No. 1
Cadmium yellow pale

Yellow ochre

Indigo

Sap green

Green-gray
Ivory black

Painting Water

Water is exciting to paint. Like the sky, it has many moods and is always changing. I am fascinated with water. I have observed water in limitless moods from sunrise to sunset. Misty, clear or muddy, I still get excited about painting it.

Certain rules must be observed. Most important, movement lines or shapes must be horizontal on the canvas or paper. Otherwise, you will create a *sloping* river or lake!

Many students worry about what color to paint water. As with all subjects, the secret is observation. Simplify shapes and tones, as you did for trees. The color of water depends on the surroundings. The shape and color of sky, trees and buildings reflected in the water determines its color. Reflected colors are slightly darker than nature.

Start sketching in pencil as you did with sky and trees. When you are out for the first time, try to find still water with good reflections. Sit down and look at the water and its surroundings. Half-close your eyes. See the shapes and tones of the reflections.

When you are confident you have simplified the shapes in your mind, sketch with a 3B pencil, or try two or three tones of pastel color. Put in reflected highlights with a kneaded eraser, using horizontal strokes to take off the pencil. This gives the appearance of ripples.

Moving water with reflections is more difficult to paint because, as with the sky, it won't keep still.

Look at the water and surroundings. Practice keeping your eyes in one place. Don't let the flow of water take your eyes with it. If you can do this, you can make out the shapes and colors of the reflections.

Water reflections stay in one place. Only reflected light, water plants and debris floating on the water represent movement. The movement breaks up the shapes of reflections and gives them strange shapes. With half-closed eyes, you can see the main shapes and forms.

Try not to fall into the trap of painting horizontal lines all over your water. This makes it artificial and contrived. Keep horizontal lines to a minimum. Use them for specific water movement or reflected light.

If you feel creative, sketch water reflections without surroundings. Let the water be the picture. Simplify the reflections to create wonderful designs and shapes. This is a good way to get to know your subject.

Don't overwork water when you paint it. If you use watercolors or pastels, you can leave paper unpainted to represent water. If you work in oils or acrylics, use thick paint only for movement or to highlight the water.

I sometimes add a reflection where none really existed. This convinces viewers they are looking at water. A puddle in the countryside can have a broken branch reflected in it—or a fence, or long

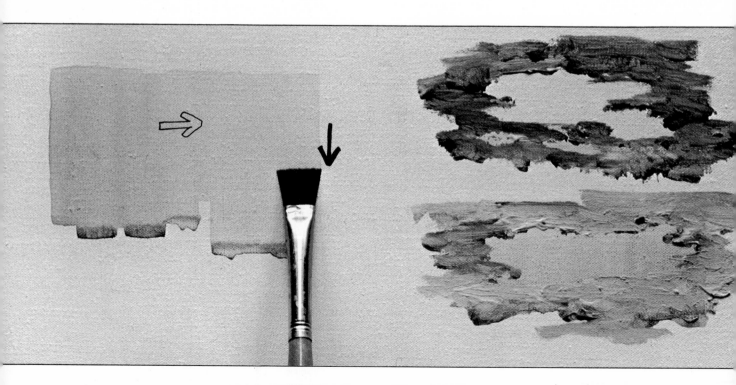

grass and so on. Use this technique when nature lets you down and you have flat water without reflections.

In the illustration at bottom left on the opposite page are two arrows, one black and the other outlined. I will use these arrows throughout the book to explain the movement of the brush. The black arrow shows the direction of the brushstroke. The outline arrow shows the direction the brush is traveling over the paper. The illustration shows the brushstroke moving vertically from top to bottom, and to the right after each vertical stroke.

The exercises at right show how you can give the impression of puddles with acrylics. First, paint the water as a watercolor wash—very wet. Paint in downward strokes. When it is dry, paint the earth around it. Keep your shapes in perspective or the puddles will not lie flat. If you want light earth, paint the water darker.

SIMPLE EXERCISES

In the exercise at top right, I have shown how you can use a reflection to portray water.

Allow the white paper to be water. With your No. 10 sable brush, paint the background field. Change to your No. 6 sable brush to paint the fence. While this is damp, paint the long grass, going over the main post. In the first stage, the white area under the fence could be anything from snow to paper. By adding reflections, it becomes water. Work the reflections with your No. 6 sable brush. Keep them free. Do not overwork them.

The second exercise at right, an oil sketch on canvas board, appears more complicated than the previous watercolor. In some ways it is, but you should be ready for it.

I have limited the colors to three plus white. Note the colors in the first stage. Work the reflected colors from the same ones.

Paint the first stage with your No. 8 bristle brush. Concentrate on the reflections in the second stage. This is an exercise in reflections. Work out the shapes between the branches with your No. 4 brush. Try to simplify the painting. Work at this one. If it doesn't come off the first time, try again.

Hold an object over your dirty water in the watercolor water container. Simplify the reflection you see. Paint it. Dirty water holds reflections together and makes them less complicated.

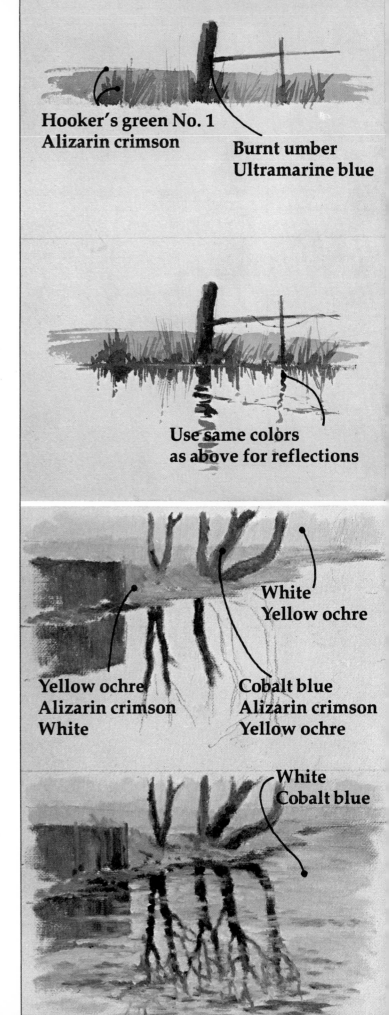

Hooker's green No. 1
Alizarin crimson

Burnt umber
Ultramarine blue

Use same colors
as above for reflections

White
Yellow ochre

Yellow ochre
Alizarin crimson
White

Cobalt blue
Alizarin crimson
Yellow ochre

White
Cobalt blue

Painting Ground and Snow

The ground in a landscape is important. It is usually the closest part of the scene to the viewer. In most cases, it is the most detailed part of the painting. That detail can be slight, depending on the subject or painting style. But often it must be a realistic, detailed likeness.

This brings us back to observation. You must learn how to observe, and the importance of it. If you can observe, you can be your own teacher. With practice, you will paint happily for the rest of your life.

Get out your sketchbook and a 3B pencil. Go into the country or your own yard. Sit, look and observe. This is where the information sketch is necessary. Sketch for information that can't be suggested. You must draw to learn what happens to things: how a fence goes into the ground, how a dirt road is formed, how grass and wildflowers grow and so on. If your drawing isn't good, try painting what you see to create the effect.

When painting close-up details, keep objects in scale. To paint a leafy tree, the leaves must be very small. You would paint the tree by defining *groups* of leaves as details, not single leaves. This is important. A painting can be spoiled if details in the foreground are out of scale.

When you sketch for this exercise, put something in your picture to denote scale. If nothing suitable is around, sketch a stool, hat or dog in the picture. It can be simple. It gives scale to your sketch, which is very important. When you paint grass and other growing things in the foreground, work your brushstrokes in the same direction as their growth and movement. Every brushstroke tells a story. Take advantage of this in close-up work.

Snow is interesting to paint, but it can be difficult to sketch outdoors. Take your car out so you can work from its relative comfort, or work at home from a window.

The stillness of a snowy landscape is enchanting. The clear rivers of spring and summer turn to brown. Trees stand out in sharp silhouette. White paper can suggest snow, and dark pencil areas can suggest trees and hedges.

Never use white paint when you paint snow. Snow is white only in its purest form—just fallen. Even then it reflects light and color from its surroundings. The whitest snow has some color. Add blue to cool the white paint or red or yellow to warm it up. Make snow darker in shadow areas. It can be as dark in comparison to its surroundings as a shadow in a non-snow landscape.

Paint snow in a low range of tones, as shown in the tonal scale below right. If the darkest shadow is a No. 10 and the brightest snow is a No. 1, according to this scale, then you should paint your snow in the range from 8 to 3. This allows you the latitude to add contrasting dark shadows and bright highlights.

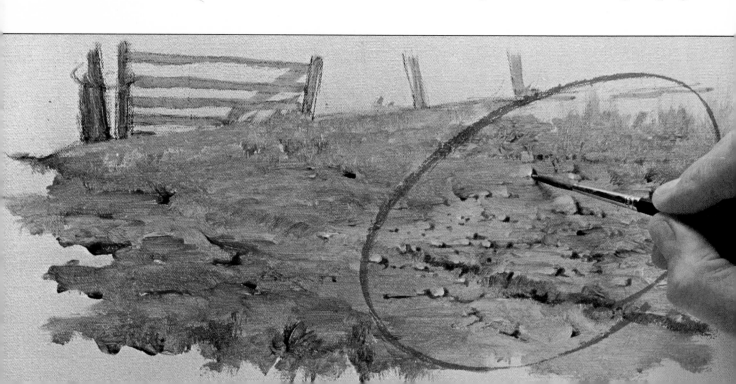

SIMPLE EXERCISES

The illustration at the bottom of the opposite page shows a simple way to paint ground. This is acrylic paint on an acrylic-primed canvas. I used crimson, bright green, cadmium yellow, raw umber, ultramarine and white. The same technique works with oils or watercolors.

Paint the area you want as mud or earth. Work your brush in a horizontal scrubbing motion. This leaves light and dark areas of different tone. If there are wheel tracks in the path, suggest these while you paint.

When this is dry, study what you have. Pick out areas in your painting that look like stones or lumps of dried earth. Paint a shadow side to them with your No. 6 sable and a watery mix of ultramarine and crimson. Then add highlights by adding white to the ground colors. The result can be remarkable.

You should now understand what I did to achieve the realism in the ground. The area I have finished is in the red circle. The area outside is how it started.

Now let's move on to the snow scene in acrylics at top right. I simplified the exercise for you by using three colors and white. The painting is on tinted paper. This enables you to see the colors you put down for snow.

Draw the picture freely with a 2B pencil. Paint the sky, distant trees and fields. Paint all the snow—until the finishing strokes—in the range of 8 to 3 shown below. I used a No. 6 nylon brush for everything except branches of the large tree. For that I used a No. 6 sable brush. Acrylics soak in rapidly on paper. To stop this, mix a little gel retarder with your paint. When you finish, highlight the snow and darkest areas. Here you move into Nos. 10, 9, 2 and 1 of the snow color scale below.

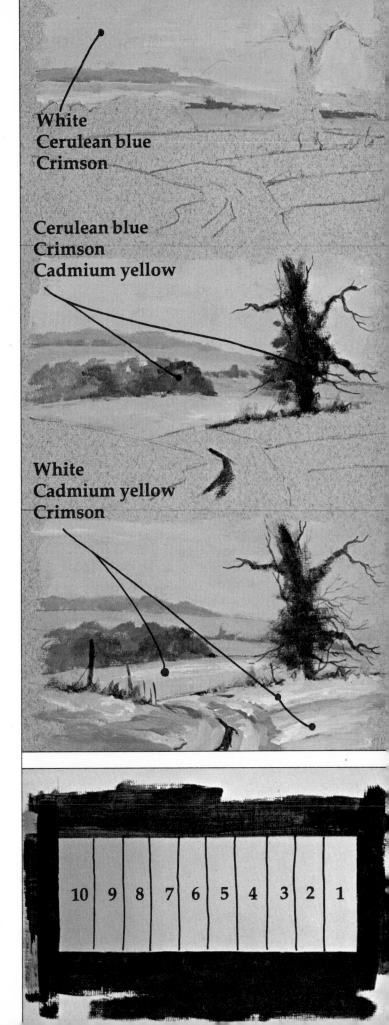

White
Cerulean blue
Crimson

Cerulean blue
Crimson
Cadmium yellow

White
Cadmium yellow
Crimson

| 10 | 9 | 8 | 7 | 6 | 5 | 4 | 3 | 2 | 1 |

Painting from Memory

Painting from memory or imagination is a common way to paint landscapes. I am sure that everyone who has sketched or painted has sat down at some time and painted a landscape from imagination.

If you paint a Martian landscape, it comes from imagination. You have never seen one before.

If you paint a landscape in the area you live, it comes from memory. Some imagination may creep in—not little green men, but perhaps a gate or an old cottage. These are things you imagine to help create your picture. But you have seen the objects somewhere, either out walking, in a book or on television.

To paint from memory is to make up a scene using memory for information. Some of this is subconscious. Imagination adds spice to the picture. What we hear, say and see is stored away in our memory. We need a "trigger" to bring it back. The smell of burning wood, a chorus of birds at dawn, a sunset—any one of these can trigger a past visual experience. My memory holds information from countless hours of working and observing outside. The more you sketch outside, the more you feed your memory and keep it active.

This way of painting is fun and exciting. You control the subject. You can concentrate on painting. You are not inhibited by copying. Cows do not get into your equipment. You don't have to keep an eye on the weather. You are in control!

Some subjects are more difficult than others to paint from memory. I paint in a representational style, so I would not paint a harbor full of boats from memory. All the technical details would test my memory to the limits!

I have a method for doing a serious painting from memory. You can devise your own method. The method doesn't matter as long as you enjoy painting. I sometimes become inspired by a sunset or early morning mist as I am driving a car. As soon as I get home, I paint the subject. I hold a vivid visual impression for about two days. Then it slides into a file in my memory to be conjured up another day.

To work in oils or acrylics, I sit in front of my easel with a blank canvas on it and a sketchbook on my knees. The canvas gives me the shape and size of what I will paint. On the sketching pad, I draw the proportions of the canvas. I usually work my sketch half the size of the painting. Then I can scale up to the canvas size.

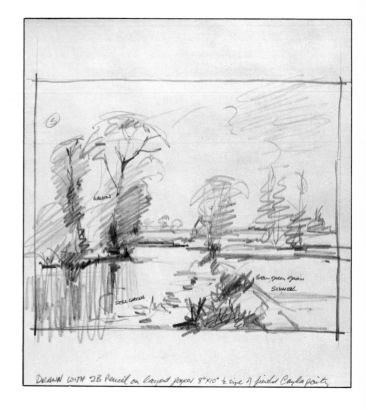

Drawn with 2B pencil on layout paper 8"x10" ½ size of finished Coyle painting

The next stage is difficult but the most important. I sit quietly and imagine different moods of nature: a hot day, a bright sunset and so on. My memory is full of these visions. Depending on my mood, one of these will surface.

If I am satisfied and at peace with the world, I probably will envision a peaceful early morning mist or warm summer evening. If I am upset about something, I may envision a stormy day with the wind blowing.

Try this as you sit quietly some evening. See if it works when you are not painting. If you find it difficult, use television scenes as a trigger. It might not be convenient to paint at that time. Hold your vision until you can paint.

Here's another way to call up a memorable scene to paint: look at family photos. You may not find the scene you will paint, but you can find something to remind you of a certain event. Everything will come back to you, including the mood of the day. Sit in front of your canvas and feel the mood. When all your thoughts and energies are on painting that mood, then you are ready to sketch.

Adding nature's mood to a painting gives it life, no matter what the style. Without mood, a painting

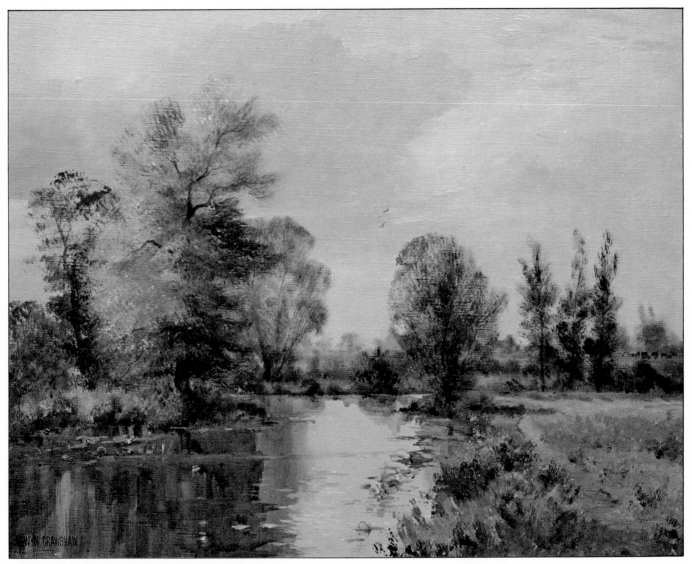

The finished painting, 20x16'', is twice the actual size of the sketch shown on the opposite page.

is dull. To decide on the painting's content, think about the scene that gave you the mood. If you don't want to paint the scene, think about the mood you have chosen. A balmy, late-summer evening calls for serenity. Avoid dramatic lines and shapes.

Now decide on the center of interest—a tree, a path, the sunset. If it is the late-summer evening, the sunset could be the center of interest. A slow-moving river might catch the sunlight. The horizon would be low because the mood is coming from the sky. In this case, the more sky the better.

Then draw the sketch. I do not draw on the canvas because I refer to the sketch throughout the painting. The painting may change as you progress, but you can always look back at the sketch. I then draw on the canvas from my sketch.

I have sketchbooks full of this type sketch. I sometimes look through them for inspiration. The sketches are the inspiration! Whenever you paint indoors, you must retain the mood of nature you are portraying, or your painting will be lifeless. If you change direction or goals while painting, don't worry. This is the beauty of painting from memory. You are in control. You create your own landscape. Your expression is uninhibited. It is an exciting way to paint.

Painting from Photographs

Photographs can't replace observing and painting actual objects. They are not a shortcut to personal experience in the outdoors.

Photographs *can* help us. As an artist, I approve of their use. But as with all painting and drawing aids, there are right and wrong uses.

I am sure Constable, Turner and other great landscape artists would have welcomed the camera if it had been available in their day. I am sure they would also have been happy to use electric light, which is frowned on by some artists.

Take advantage of modern technology. After all, we accept nylon brushes. The only nylon I remember 25 years ago was for nylon stockings. We accept acrylic paints and use paints in tubes. It hasn't always been like that.

It is difficult to generalize about photographs. You must experience events with your photographs. I use photographs in two ways: as *information sketches* and *atmosphere sketches*.

I bring my camera when I go on a sketching trip. After sketching the scene, I take a photograph from my sketching position. Depending on the subject, I may photograph specific details. When I work from the sketch at home, I can refer to the photograph for detail information. I always take slides, not prints. Slides give more detail and depth. You can project a slide to a large image if you want. To use a slide for reference while I paint, I hold it in a small hand-viewer.

The photographs I use as atmosphere sketches record moods of nature that I don't have time to sketch. Occasionally, you might not have your camera with you. Try to observe the scene carefully and store it in your memory for future work.

Don't copy a photograph, even if you intended to use it for information only. It will lack life, feeling, expression and originality.

I have heard teachers suggest that a photograph is best to copy when it is out of focus because details are not visible. I don't agree with this. To be able to paint, you must know what you are painting. If the photograph is out of focus, you don't know what to re-create. You might paint a "stone wall" in a field when it actually is a hedge. This is a shallow way to work. You are merely copying images from a photograph, and this is wrong. Get as many clear details as possible in your photograph.

You be the judge of what to put in or leave out. Create *your own* experience, not the camera's.

If you photograph from a sketching position, you will notice a difference compared to the sketch. You will bring the distance and middle-distance much closer and larger in your sketch than in the photograph.

Compare the sketch and photograph on the opposite page. The sketch of the church was done before the photograph was taken. I was surprised at how small the church was. I could hardly make out the fishermen on the river bank. I think the reason is that the camera sees everything. *You see only what you want to see.* This is why your painting differs from the next artist's, even if you paint the same view.

In the church sketch, I was not concerned with the fence or the boy standing on the ice. I wanted to capture the church in the cold morning mist and the fishermen standing, waiting, frozen. I knew how they felt. The sketch took 20 minutes and my hands were frozen, too.

Don't fuss and worry about the photograph or the camera. You are learning to be a painter, not a photographer. When you are sketching, the camera is a tool to record information, not to make pretty pictures.

Concentrate on your drawing or painting, not on the camera. The best way to get over this tendency is to use a simple camera. All you must do is press a button and the picture is taken. If you want to use the camera and be a photographer, don't take your sketchbook. Painting and photography need undivided attention. They are different creative forms of art.

When I teach, students often ask meekly, "Can I use photographs?" They look around to see if anyone has overheard. This confusion about the use of photographs should be dispelled. It is not wrong to use photographs, but use them correctly.

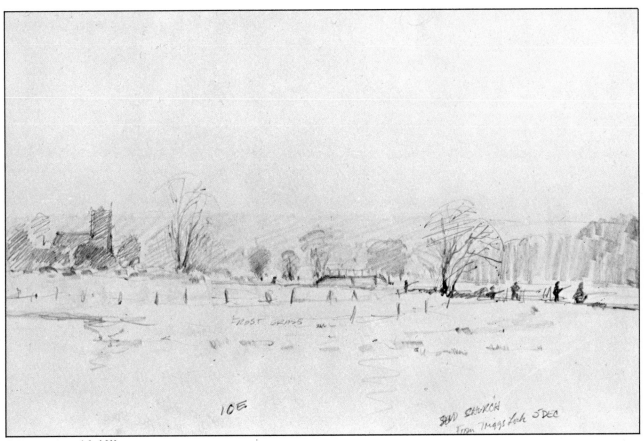

Pencil sketch, 16x12''.

A portion of my photograph of the scene.

Pencil Sketching Outdoors

Below are the two most common types of sketches: the information sketch and atmosphere sketch.

Common-sense rules apply to working in cold weather. The biggest mistake is not to wear proper clothing for the season. You will do better work if you are comfortable.

Keep your sketchbook in a plastic bag to protect your sketches in wet weather or near water. You will need two or three pencils, a knife to sharpen them and a kneaded eraser.

When you see a spot for sketching, you may be tempted to walk to another spot to see if the view is better. When you get there, you will want to go somewhere else, and so on. Eventually, you may come back to the same spot, or search so long that you don't sketch anything! This sounds ridiculous, but I have done it on many occasions. When something attracts your attention enough to sketch it, get right to work. If you have enough time when you finish, move to another location.

It is sometimes difficult to know where to begin and end the sketch of a scene. Cut a frame out of paper or cardboard with an opening about 6x4", as shown on the opposite page. Match the shape to your sketchbook proportions so your picture fits nicely on your paper. Hold the frame up at arm's length. Close one eye. Move your arm backward, forward and side-to-side until the scene looks right in the opening. Note the position of your arm. Remember key points where the scene hits the inside edge of your frame. This helps to compose the picture, as shown in the illustration at top right. Position the main features, and relax your arm. Put the mask away and draw your sketch.

Use this method to find a scene to paint. Move the cardboard around in front of you until it frames a section of landscape that inspires you to sketch. If you forget your frame, make a square with your hands and look through them.

Information sketch, 7x7".

Atmosphere sketch, 7x7".

Pencils are important. The type you use is a personal choice, but a good range for sketching is from HB to 6B—hard to soft, light to dark. You will find pencils that suit your work. To start, I recommend an HB pencil for clean line work and a 3B pencil for shading rapid, free expressions and light or dark tonal work.

The photograph at bottom right shows the tones you can get with seven different grades of pencils, using the same pressure on drawing paper. I used a 3B pencil to show the tone variation from light to dark.

Practice shading with your pencil. Shading will make your sketches lively. The pencil is what creates the image on paper. I suggest you use an HB and a 3B pencil. A 2B grade is a good general-purpose one to carry around in your pocket. You can make it do almost anything.

The photograph shows proper points for an HB pencil and a 3B pencil. Leave a long, gradual taper to the lead and enough lead showing so you can see the point when you work. The circled pencil is sharpened the wrong way. It's too stubby.

Observe common courtesy whenever you sketch or paint in the country. Close gates behind you, don't walk over crops and don't take souvenirs. Ask permission to go on private land.

When you are out sketching, remember that at home you must understand what you drew—without the model.

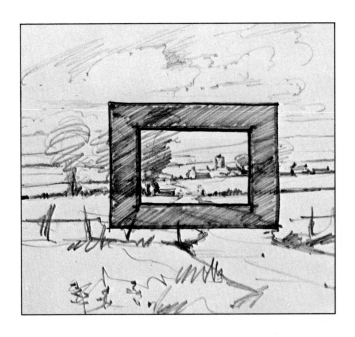

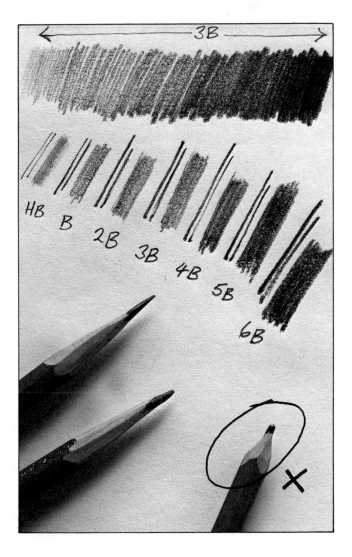

Pencil Sketching on Location

In the following pages, I have done nine exercises for you to follow and copy. I explain the work step-by-step from first stage to last. This allows you to see each painting as it develops. Compare each stage with earlier ones.

It is important that you know the size of the finished painting, not the reproduction. This gives you a scale to understand the work. The actual size is indicated under the final stage. Close-up details of each exercise are reproduced at their actual size. You can see the brush or pencil strokes. These details focus on the method you should study for a particular part of the painting.

I have painted these subjects in my own style, which has evolved over the years. The exercises are patterned after the way I work. You will develop a creative style of your own. When you master the medium, let your own style come out.

This exercise re-creates a normal sequence of events: going to the country, preparing pencil sketches—in this case an atmosphere sketch and an information sketch—and working from the sketches at home. In the next exercise, we will work from the same sketch in acrylics.

I photographed the scene, which is reproduced below.

First Stage—With your 2B pencil, draw the main features of the picture on paper. Try not to rub out lines you think may be wrong. Go over and correct them with your pencil. This helps build character and depth in your sketch.

Second Stage—Work on the tonal areas of the trees by the cottage and on the left river bank. On location, you should half-close your eyes to see the tonal values—light against dark. Don't labor this sketch. Scribble away freely with your pencil. Try to create an atmosphere, not a detailed drawing.

Final Stage—Shade in reflections with downward strokes of your 2B pencil. Work the plants on the right foreground bank freely. Take out some horizontal lines in the reflected water with your kneaded eraser. Add a few horizontal strokes to the water with your pencil.

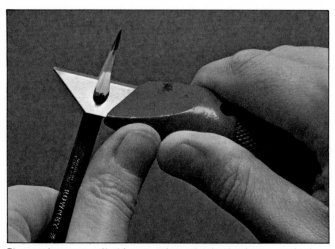

Sharpening a pencil this way gives the lead a long, gradual taper. You can see the point easily as you sketch.

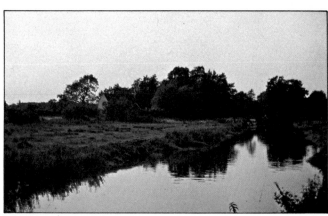

My photograph of the scene.

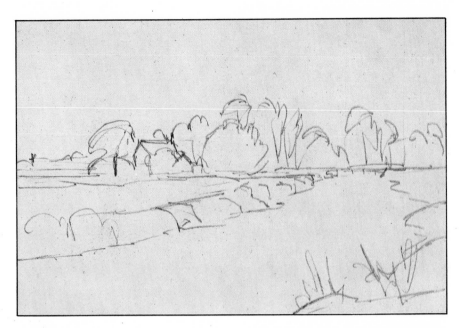

First stage

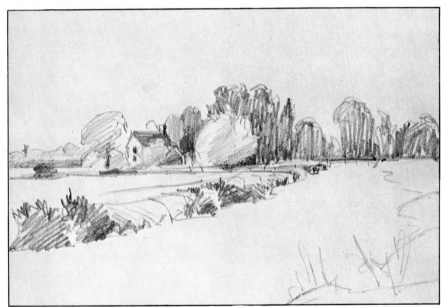

Second stage

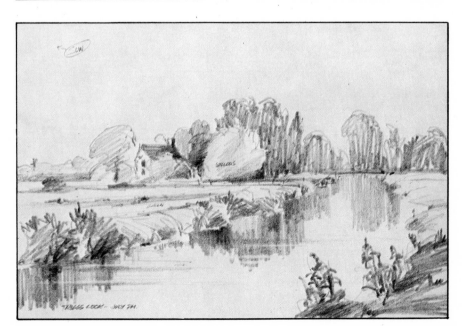

**Final stage
12x8''**

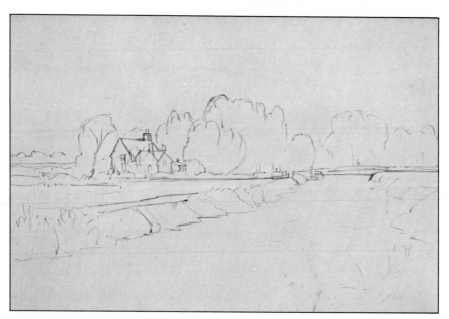

First stage

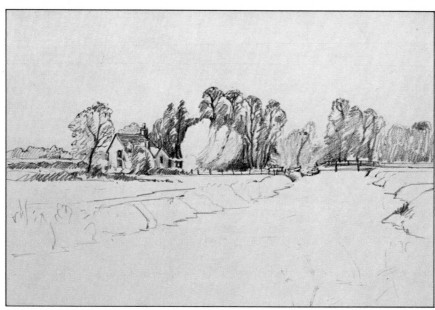

Second stage

Now work the same subject as an information sketch. The key factor is *observation*.

First Stage—Use your HB pencil to draw the main features—the cottage, the middle-distance trees and the river banks.

Second Stage—With your 2B pencil, start left of the cottage. Draw the distant fields. Work to the right, shading in the trees as you did in the first sketch. This time put more shape and form into them. Draw the trunks and main branches. Add details with your HB pencil. Put in the fence, the two boats on the bank, the two in the water and the footbridge in the distance.

Final Stage—Put in reflections with downward strokes of your 2B pencil. Draw a few horizontal lines to give the river movement. Use the kneaded eraser as you did in the first sketch. Draw plant life on the river banks. Put in more details than you did on the atmosphere sketch. At this stage, start a new page and draw some of the close-up plants much larger. This will give you more information when you paint from your sketch at home.

Your sketch is all you have when you return home. Be sure to get all the information you need. Your last step is to review the scene and your sketch. Change or add anything you need to make it understandable. Write notes if you need to.

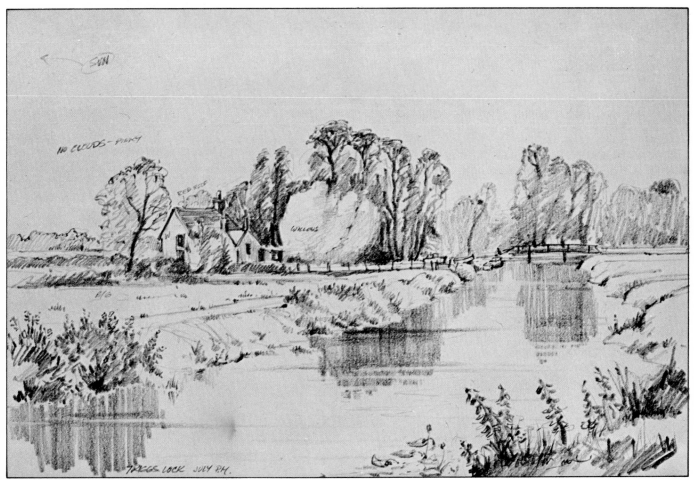

Final stage **12x8''**

Detail of atmosphere sketch.

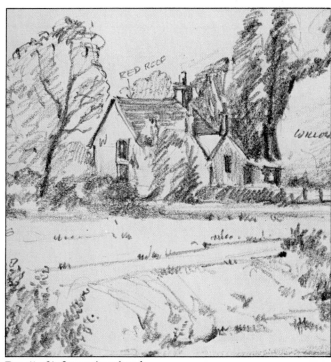

Detail of information sketch.

Painting in Acrylics from a Pencil Sketch

Now you can start painting. Don't begin until you feel confident. If you aren't ready, repeat earlier exercises before tackling this one. Start with another exercise if you prefer watercolors or another medium.

To mix colors in these exercises, mix into the first color I mention. Add smaller amounts of other colors to the first one. The first color is usually the main color. White is most often last unless it is the main color.

Acrylic or oil colors are listed with some exercises to show the main colors in those exercises.

This is the same subject you sketched in the preceding exercise. The painting is on acrylic-primed canvas.

First Stage—Draw the picture with your HB pencil. Work the main areas as you did in the earlier sketches. Don't try to draw the trees or the banks of the river in detail. Leave this for your brush. Mix cerulean blue, crimson and white. Start at the top of the canvas with your No. 12 nylon brush. Work from left to right as you paint down to the horizon. Add more crimson, white and cadmium yellow behind the trees. Paint the river areas with the same colors.

Second Stage—Start with the distant trees on the left of the house. Use your No. 2 nylon brush and a mix of ultramarine, a little crimson, cadmium yellow and white. Paint the field under these trees with cadmium yellow, crimson and white. Paint the hedge in front of the field to the house with the same brush and a strong mix of ultramarine, crimson and cadmium yellow. Paint the start of the field underneath this hedge using bright green, cadmium yellow, ultramarine and a touch of crimson and white. Paint the house roof with cadmium red, cadmium yellow, a little bright green, ultramarine and white. Paint the wall of the house with white, cadmium yellow and crimson. Use crimson and ultramarine for the dark area of the wall. The row of trees behind the house and to the right are next, but leave out the willows. Use your No. 4 nylon brush and a mixture of ultramarine, crimson, bright green and white. Change the ratio of the colors in the mixture to vary the colors of the trees. Use more white for the distant trees. Thin the paint at the top of the trees to let the sky show through. Don't emphasize details, only shape and form. Paint the willow trees with the same brush, mixing cerulean blue with bright green, crimson and white. Add shadows to the willows with less white. Put in the tree on the left of the house using the colors of the trees behind the house and your No. 4 brush. Use the *drybrush* technique for this tree. This means you dry out your brush more than usual, and load it with paint. Work the excess paint off on your palette, then *drag* the brush over the painting surface.

Third Stage—Paint the front of the house with your No. 2 nylon brush and a darker mix of the roof colors. For the shed on the right, use ultramarine, crimson, raw umber and white. Paint the trees in front of the house with your No. 4 nylon brush and a mix of bright green, ultramarine, crimson and white. With your No. 2 nylon brush and a varying mix of cadmium yellow, crimson, bright green and white, paint the field under the middle-distance trees. Now use your No. 4 nylon brush to paint the field down to the river-bank path in the foreground. Darken the field under the trees. Paint the path with your No. 4 nylon brush and a mixture of cadmium yellow, crimson and white. Paint the reflections in the water with your No. 6 nylon brush. Mix ultramarine, crimson, bright green and a touch of burnt umber with lots of water. Apply the paint in washes

Sky and water

Cerulean blue
Crimson
White
Cadmium yellow

Dark trees

Ultramarine
Crimson
Bright green
White

Grass

Cadmium yellow
Crimson
Bright green
Ultramarine
White

First stage

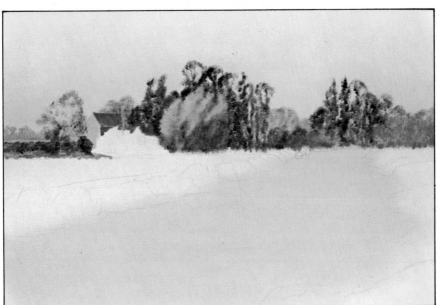

Second stage

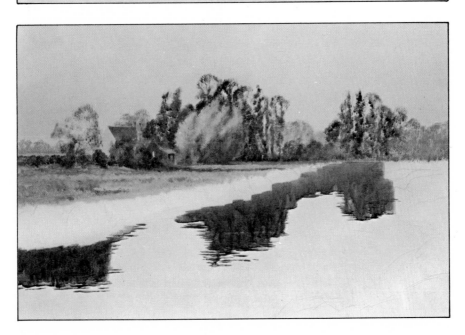

Third stage

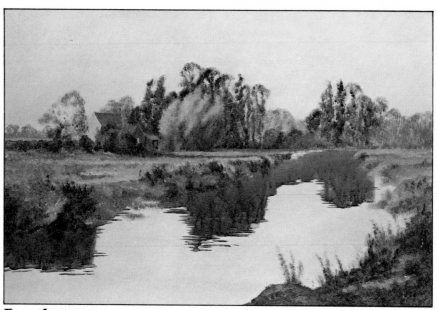

Fourth stage

with downward strokes, as shown on page 24. Finish with horizontal strokes to break up the reflections. If the watery paint puddles on your canvas, dry your brush out and blot the paint up. Apply another wash of paint after each one dries. I used four washes on this painting.

Fourth Stage—The left river bank is next. Paint some of the plant growth. You will be pleasantly surprised at what free brushstrokes can create. Work the brush in different directions. Push it against the natural flow of the bristles. Stab and twist the bristles to create different effects. When you mix colors, make more than one at a time. Mix varying colors and tones as you work along the bank. Use your No. 4 nylon brush and bright green, ultramarine, crimson, raw umber, cadmium yellow and white. Work from the bridge to the foreground. Now, with the same colors you used for the left field plus ultramarine for dark areas, paint the right field and bank with your No. 4 nylon brush. Paint the dry mud first, using cadmium yellow, crimson, burnt umber and white. Use your No. 2 nylon brush to suggest plants in the foreground. Drag the brush into the water area.

Final Stage—Use your No. 6 sable brush for details. Work the trunks and branches of trees using your tree colors. With the same colors, paint windows on the house. Use white, cerulean blue and a touch of crimson to paint the light water behind the bridge with horizontal strokes. Paint the bridge with

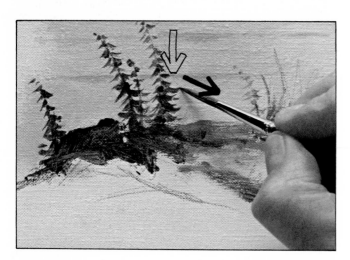

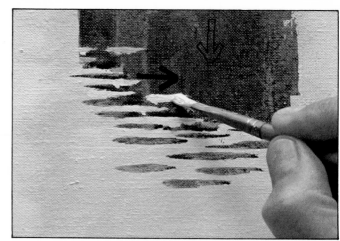

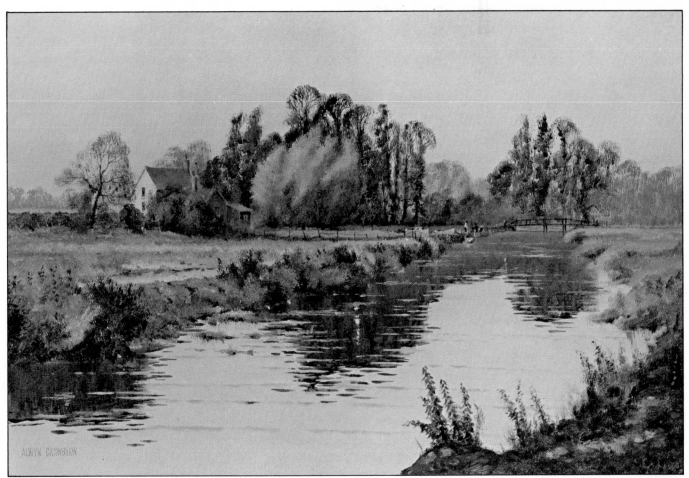

Final stage 24x16"

the same brush. Use cadmium yellow and white for the boats on the bank. Use ultramarine, crimson and cadmium yellow for the ones on the river. Now work on the bank. Bring out leaf shapes with dark colors over light areas, and light colors over dark areas. Using white, cerulean blue and crimson, drag your brush across the middle-distance of the river to form ripples. With your No. 2 nylon brush and the same colors, work downward, painting into reflections. With the reflection colors, paint some dark horizontal lines into the light areas, breaking up reflections. Put in weeds on the left side of the river, using bright green, cadmium yellow, crimson and white. Now use your No. 6 sable brush to put in details on the plants. Put in leaves with single brushstrokes. Work the brush outward from the stems. Now put in the vertical highlight on the water and the two men by the boats. These are single brushstrokes of light and dark colors. Finally, look at the painting with a fresh perspective. Add highlights and dark accents where you think they are necessary to finish *your* painting.

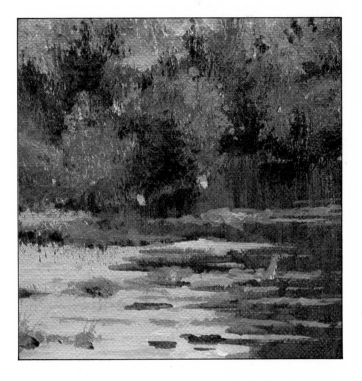

Watercolor Sketching Outdoors

Watercolor sketching can be an extension of pencil sketching. You can do a pencil drawing as you do a pencil sketch, only use less pencil shading and add watercolors for color reference. A watercolor sketch is a watercolor painting in its own right. The medium can be difficult, as with any other. But if things go wrong, there are ways to overcome them. We will discuss these later. At worst, you must start again. I have had to quite often! Aspire to create a watercolor *painting* when you do an outdoor watercolor sketch.

You need your paints, brushes, sketchbook or drawing paper, pencil, kneaded eraser, water container, cardboard frame and sponge. A stool may be necessary. You need an equipment holder, which can be anything from a plastic bag to a specially made case.

Years ago my daughter made me a customized carrier from the leg of an old pair of corduroy trousers. She used one pocket for my water container—a plastic medicine bottle—and another pocket for my water jar, an old tobacco tin. We chose these containers because they fit into the pockets. The leg is folded in half to provide two large storage spaces. One holds my sketchbook. The other holds my watercolor box and a case with everything else.

The contents are sable brushes, pencils, kneaded eraser, sponge, rubber bands to hold down sketchbook pages on windy days, a knife, and adhesive bandages and aspirin.

The carrier is pictured on the opposite page. It is compact when packed. My sketching kit is a miniature, portable watercolor and drawing studio. For a special trip, I carry an additional drawing board for large sheets of watercolor paper, a stool and my camera. You may need an easel. If so, lightweight portable ones are available. I am satisfied to rest a board or sketchbook on my knees.

I painted the Henley Royal Regatta last summer. This was to be a watercolor information sketch for a 40x20" studio painting in acrylics. The photograph on the opposite page, top, shows me working. You can see how simple my equipment is for outdoor work.

The second photograph shows my view of the regatta. The finished watercolor sketch is at bottom. Compare the photograph and the painting. My eye brought the view closer.

These information sketches show two watercolor techniques. Above, I used white paint to make the figures opaque. I put in the figures after I painted the field. Below, I added black felt-tip pen to bring out detail. Both are 7x5-1/2".

Don't rush a watercolor sketch. Look at the scene, analyze it, decide how to paint it—and then start. If it goes wrong and you have time to start again, do so. If not, there are three ways to salvage your work. Carry a pen and black waterproof ink, or a black ball-point pen, a black felt-tip pen, or a fountain pen with black ink and a tube of white designers' gouache.

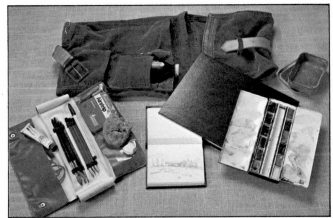
Only a few materials are needed for sketching.

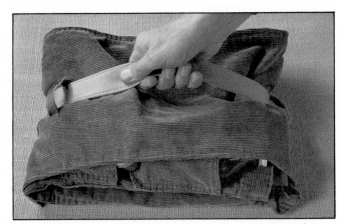
My sketching materials fold up in a handy homemade carrier.

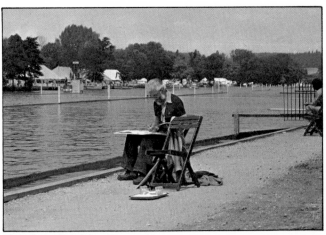
Here I am sketching the regatta.

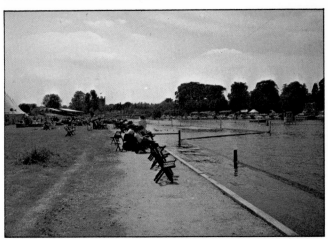
This is the view I had of the river scene.

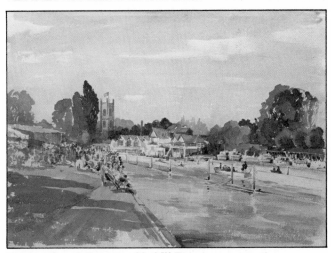
Henley Royal Regatta, 20x15''.This is a watercolor information sketch.

The first method is to leave your painting for half an hour, then come back to look at it with a fresh eye. It may look better than you thought. If you want to get more out of it, go over your work with a pencil as though it were a pencil sketch. This sometimes can revive your painting and give life to a flat, uninspiring watercolor.

The second method is a technique for finished paintings. Add pen-and-ink to the painting. Draw over the unsuccessful watercolor in pen and make a *pen-and-wash drawing* of it. The color will show through, and you may have a pleasing sketch.

The third method is to add white to your colors. This makes them opaque. You can overpaint your troubled areas. This also is a technique in its own right—*opaque watercolor painting.* You can finish the painting this way.

All is not lost when your watercolor goes astray. But if you want to be a watercolorist, treat these methods as emergency escapes, not as easy ways out of a problem.

Don't make notes on a watercolor sketch. You might decide to use it as a finished painting. Make your notes on the back, if the paper is thick, or on separate paper.

Painting a Watercolor on Location

In this exercise, we will paint Salisbury Cathedral as an information sketch. In the next exercise, we will use the sketch to do a larger acrylic painting.

This is a pure watercolor without the aid of pen-and-ink or white paint. A pure watercolor sketch is a finished watercolor painting, so don't write comments on it in pencil. This doesn't mean that a pen-and-ink sketch can't be a finished painting. It is as finished as a watercolor, but it is not a *pure* watercolor. I find it more challenging to attempt a pure watercolor first. If it doesn't look right, I can add pen-and-ink or white.

I photographed the subject so you can see what license I took with my painting. If you lose control of this watercolor, don't throw it away. Use pen-and-ink, pencil or white paint to save it.

Keep your sketches, no matter how bad you think they are. Sketches have something to say, especially if they are done from nature. Refer to them, if only to see how you have improved!

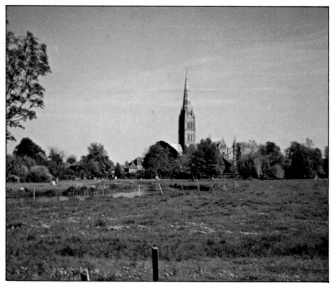

A portion of my photograph of Salisbury Cathedral.

First Stage—Draw the picture with your HB pencil. This sketch is on 140-pound, cold-pressed watercolor paper pinned to a drawing board. The paper was not *stretched* first. Stretching involves wetting the paper, then allowing it to dry before you paint. Dampen the sky with a sponge or large brush. Do not go over the cathedral steeple or into the trees. Load your No. 10 sable brush with a watery mixture of cerulean blue and a touch of alizarin crimson. Apply this wash to the damp paper. Work the brush in broad strokes. Add a touch of yellow ochre as you move downward toward the horizon. Don't paint the steeple.

Second Stage—Use your No. 6 sable brush and a mixture of yellow ochre and alizarin crimson to paint the steeple and stonework of the cathedral. Sunlight is coming from the right side of the picture. The shadows on the cathedral will be put in at a later stage. Paint the roof of the cathedral with a wash of cerulean blue and cadmium yellow pale. Mix cadmium yellow pale, alizarin crimson and a touch of Hooker's green No. 1 with the same sable brush. Paint the roofs of the buildings. Paint the buildings with a watery yellow ochre. Now, with your No. 10 sable brush and a wash of Hooker's green No. 1, Payne's gray, alizarin crimson and a touch of cadmium yellow pale, paint the trees from left to right. Vary the paint colors and tones. At this stage, use only one wash for all trees except the dark ones in front of the cathedral. This is the painting's darkest tone.

Third Stage—Carefully observe the tree shapes to be defined with the next wash. When you start, don't copy exactly or you will lose the spontaneity and freedom of a simple wash. Remember, you are painting the forms and shapes of trees. Use your No. 6 sable brush and strengthen the colors you used for the first wash on the trees. Use ultramarine blue in place of Payne's gray. Put in the windows and shadows on the buildings with the same brush and the same colors. Paint the wall in front of the cathedral to the right of the dark trees with a wash of alizarin crimson and yellow ochre. Paint the field on the left bank of the river with your No. 6 sable brush and a wash of cadmium yellow pale, Hooker's green No. 1 and alizarin crimson. Leave small white areas to work people in later.

Fourth Stage—Add form and dimension to the cathedral steeple. Use your No. 6 sable brush and a mix of ultramarine blue, alizarin crimson and a touch of yellow ochre to paint the shadow side of the steeple. With the same brush and color, suggest windows and molding on the cathedral. Don't be fussy with these details. If it is too detailed, it will

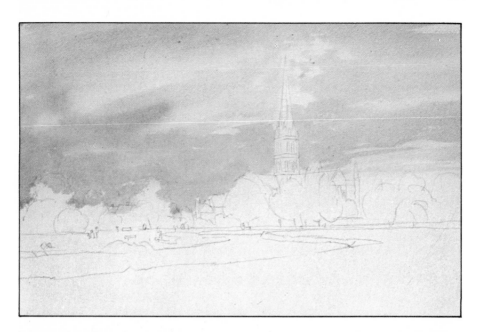

First stage

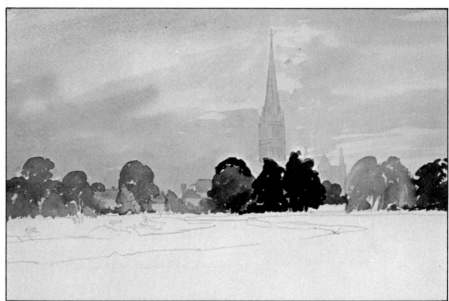

Second stage

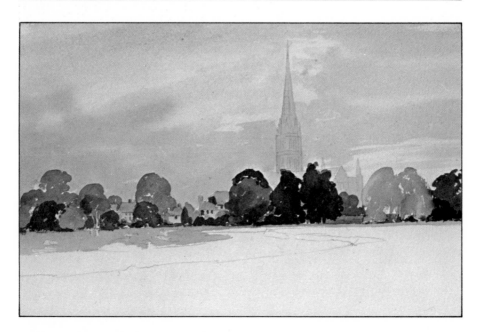

Third stage

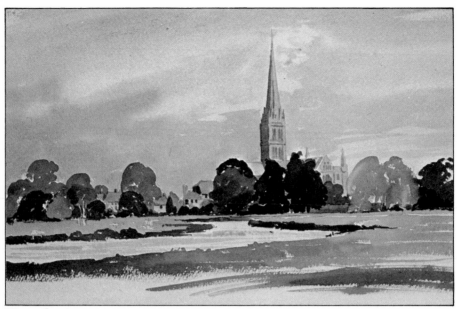

Fourth stage

jump out of the middle-distance, where it belongs. Work the river banks with the same brush. Use the field colors, but add Payne's gray. The river is fast-moving and rippled. Using your No. 6 sable brush, mix cerulean blue and alizarin crimson. Paint the water with horizontal brushstrokes. Leave plenty of white paper showing. Paint the right field up to the foreground with your No. 10 sable brush, plenty of color and water, and free brushstrokes. Use cadmium yellow pale, alizarin crimson, Hooker's green No. 1 and a touch of ultramarine blue.

Final Stage—In this sketch, I put in a suggestion of a steeple reflection. I thought the watercolor sketch could use it. I chose to leave it out of the acrylic painting in the next exercise. To put in the reflection, use your No. 6 sable brush and the color you used for the steeple. While it is wet, take out the bottom of the reflection with blotting paper. Then paint the reflections of the left bank with the colors of the river bank. Use horizontal brushstrokes. Use your No. 6 sable brush to paint figures in the field. Use dark colors. Leave some white areas showing. Use any colors you like for the people. Put in details you think necessary on the cathedral. Add dark accents under the trees. With your No. 10 sable brush, paint the foreground field with definite, unlabored brushstrokes. Use the same colors, but stronger.

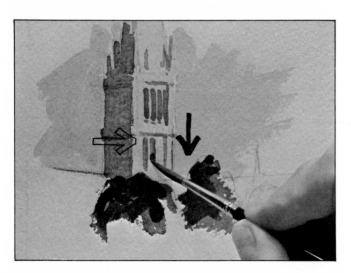

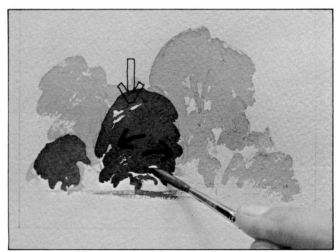

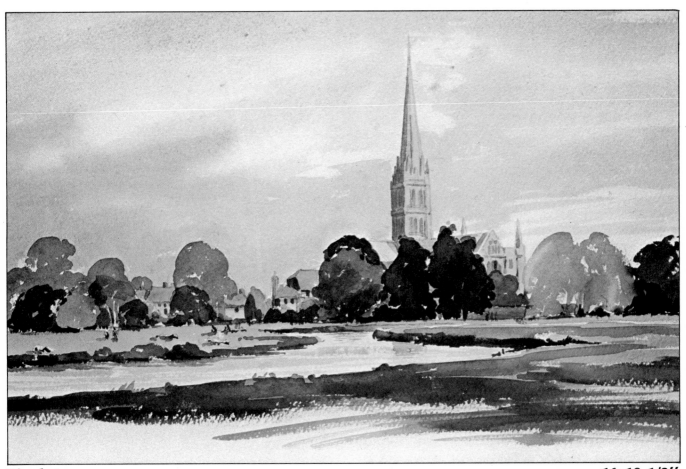

Final stage **16x10-1/2''**

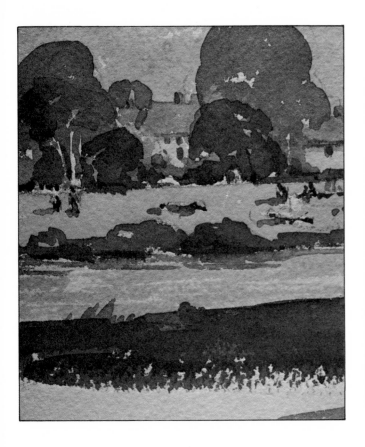

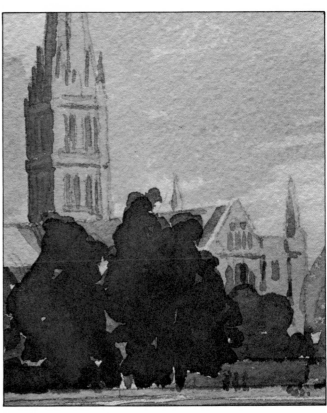

Painting in Acrylics from a Watercolor Sketch

Working at home from a sketch drawn on location allows you to be familiar with your subject. If it is a colored sketch, like this one of Salisbury Cathedral, you have explored the subject. When you do it again at home, time is on your side. You can rethink where the paint might be worked differently.

When you painted the river banks in the preceding watercolor exercise, I told you how to get varying effects of plants and grass. You worked your brush in different ways. To paint a landscape with acrylics, I have special "tree brushes" to get natural-looking effects. These nylon brushes are old and have gradually assumed their ungainly shapes. They are shown below. Use an old, worn-out brush—if you have one—to work trees and grass on this painting. Experiment on paper first. This painting is on acrylic-primed canvas.

First Stage—Draw the main areas with an HB pencil. Paint the sky, using your No. 12 nylon brush and a mix of ultramarine, crimson, a touch of raw umber and white. Start at top left and work across and down. Vary the tones as you work. Add raw sienna to your mix as you move down the canvas. Make the sky on the right side of the steeple darker than on the left side. Work the light area to the left of the steeple with plenty of white, raw sienna, crimson and a touch of cadmium yellow. Let the sky go over the drawing of the trees. Use less white where you want the sky darker. Add white where you want it lighter.

Second Stage—Start at the top of the steeple and work down the shadow side with your No. 6 sable brush. Then work on with your No. 4 nylon brush. Use raw sienna, ultramarine, crimson and white. Paint the light side the same way, using raw sienna, cadmium yellow and white. Paint the end of the cathedral with the same colors. Mix cerulean blue, bright green and white. With your No. 2 nylon brush, paint both roofs of the cathedral. With your No. 4 nylon brush, paint the building roofs using cadmium red, cadmium yellow and white. Next paint the building walls using the same colors you used for the cathedral's light side. Put in the windows and shadows of the steeple and buildings. Use your No. 6 sable brush and the colors you used for the dark side of the steeple.

Third Stage—Put in the distant trees on the left of the cathedral. Use your No. 4 nylon brush with ultramarine, crimson, bright green and white. Add cadmium yellow to these colors for the nearer trees. Work from left to right. Change the consistency of these colors to vary the trees. Use more paint on the darker trees in front of the cathedral. Add raw umber and less white for the dark areas. Work each tree as your own. Don't copy my trees or the ones from your watercolor sketch. Paint the reddish-brown wall in front of the cathedral with cadmium yellow, crimson, ultramarine and white. Use your No. 4 nylon brush to paint the wall behind the dark trees and under the willow trees. Paint the willows, using white, cadmium yellow, bright green and a little crimson. Work the brushstrokes outward from the tree's center in the direction the leaves fall.

Sky
Ultramarine
Crimson
Raw umber
Raw sienna
White
Cadmium yellow

Steeple
Raw sienna
Ultramarine
Crimson
Cadmium yellow
White

Trees
Ultramarine
Crimson
Bright green
Raw umber
Cadmium yellow
White

MY 'WORKED IN' BRUSHES — FOR TREES

First stage

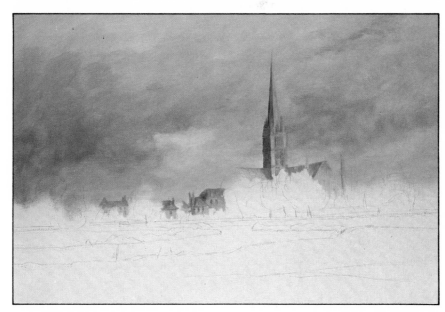

Second stage

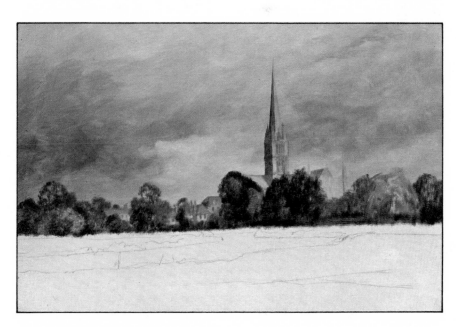

Third stage

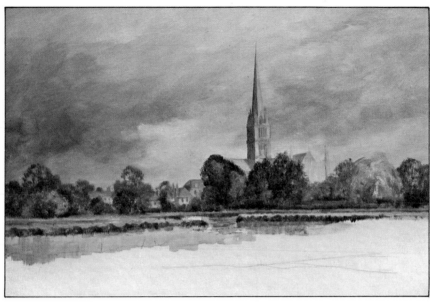

Fourth stage

Fourth Stage—Start with the field on the left bank. Use your No. 4 nylon brush and a mix of bright green, raw umber, cadmium yellow, a little crimson and white. Vary these colors as you paint the field. Paint the bank, using the same brush with ultramarine, bright green, crimson and a little raw umber. Add white to lighten areas. Now paint the river with a watercolor-wash technique as you did in the preceding exercise. Use your No. 6 nylon brush and a wash of ultramarine, crimson and a touch of bright green. Paint the field to the right of the river and bank. Use the colors you used for the first field.

Final Stage—Paint the foreground field next. Start at the top and work down. Use your No. 4 nylon brush. Drag a mix of bright green, cadmium yellow, crimson, raw umber and white down the canvas. Add ultramarine for the darker areas near the foreground. Work the brush up and down to show grass. Let the brush go into the last grass you paint. To paint plants, use the *edge* of the brush and upward strokes. Use the principle of light against dark. This helps make the grass appear long and summery. Put in some buttercups and dandelions with your No. 2 nylon brush and cadmium yellow, a touch of crimson and white. Paint the main tree trunks in the middle-distance with your No. 6 sable brush. Now put in the people. Use your No. 6 sable brush and paint them in one stroke. Start at the head. Drag the brush down as if you were drawing with a pencil. Choose your own colors. Light against dark or dark against light helps make the figures show up. Add details to the cathedral with your No. 6 sable brush. Keep the work light and free, or it will stand out too much. Use the same colors, but darker. Tone down the cathedral roof. Next, paint the highlights on the river with horizontal strokes. Use your No. 2 nylon brush and white, cerulean blue and a touch of crimson. Put in the fence with your No. 6 sable brush and a mix of burnt umber, bright green and ultramarine. Look the painting over. Add highlights and dark accents where you think necessary.

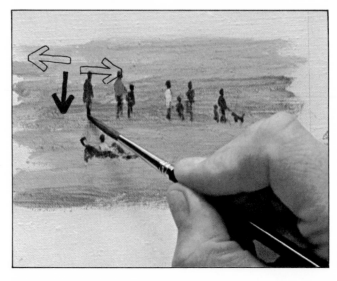

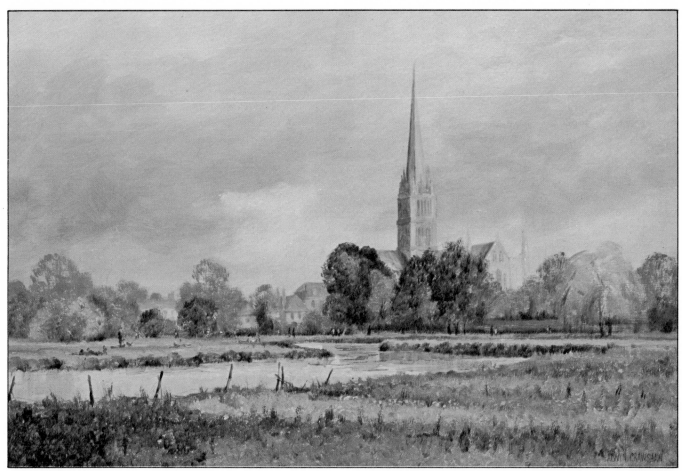

Final stage 24x16″

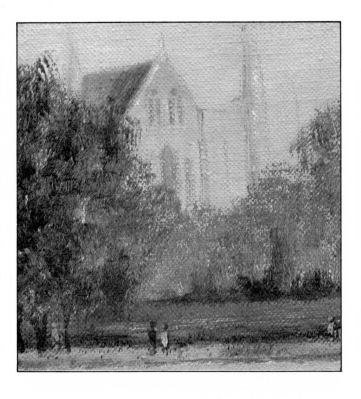

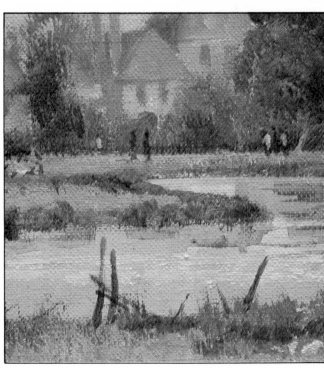

Painting Mountains in Oils

Most artists attempt to paint mountains at some time. Mountains excite you with their size and majesty, with their loneliness and with the contrast of light and dark. One thing I like in a mountain picture is something to show scale. In the picture you are about to paint, the village at the foot of the mountains shows scale.

For this oil painting I used a gel medium to make the paint dry quicker on the canvas. I mixed this with colors as I went along. The painting was done in one sitting without any problem with the paint being too wet to work over. I worked directly to avoid overpainting. This is my natural style.

I used four colors and white for this picture. One of them is alizarin crimson, a strong color. Only touch your brush into it when you are mixing.

Some artists mix oil paints on the palette with a palette knife. They use their brush only for painting. There is nothing wrong with this practice. The end result is what matters, not how we get there. I mix my paints and work on the canvas with the same brush. I use a 50-50 mix of turpentine and linseed oil as my mixing medium. I clean my brushes with turpentine.

First Stage—Use your HB pencil to draw the picture. With your No. 10 brush, mix white, cobalt blue, yellow ochre and a touch of alizarin crimson. Start at the top of the sky and work down. Use less white in the shadow under the cloud. Work the darker paint into the light area for a soft cloud effect. Paint the middle mountain. The sky will be painted over this. Use cobalt blue, alizarin crimson

and touches of yellow ochre and white. To paint this and other mountains, let your brushstrokes follow the contours and fall of the mountain.

Second Stage—Paint the clouds under your first big cloud using the light colors. Work the paint over the mountain parts you just finished. Leave some hard edges to show its form. Work dark cloud color into the shaded area of the top cloud again. Drag the brush into the light cloud below to show rain. Still using your No. 10 brush, paint the mountain below, which is in the sun's shadow. Paint the one behind the village. Use cobalt blue, yellow ochre, a little viridian and white. On the left side, use more white with your colors where the sun is hitting the mountain. Work dark and light areas as you paint the mountain. Let the brush follow the mountain contours. Use darker colors on the lower mountain area in shadow. It is closer to you.

Third Stage—Use your No. 8 brush throughout this stage. Vary your mixture of yellow ochre, alizarin crimson, viridian and white for sunlit areas. Mix cobalt blue, alizarin crimson, yellow ochre and a little white for shadows. There are too many steps to explain this stage in brush-by-brush detail. Follow these simple guidelines and you will manage very well. First, don't try to copy my brushstrokes exactly. Let your natural brushstrokes shape the mountain contours. Second, paint the shadow shapes first. Then work the light areas to blend into the shadow areas. Third, work on each mountain or part of a mountain separately. Finally, make the left foreground mountain dark. It is in strong shadow.

Fourth Stage—With your No. 4 brush, paint trees behind the houses. The painting is in spring. Most of the trees are without leaves. Paint them thinly at this stage—not too much paint. Work on dark and light trees. For dark trees, use cobalt blue, alizarin crimson and yellow ochre. For light ones, use yellow ochre, alizarin crimson and white. Use downward brushstrokes. Work from left to right. Work the trees up the hillside under the dark mountain at left. Paint the roofs of the houses using the same brush, with cobalt blue, a touch of alizarin crimson and some white. For the walls of the houses, mix white with a touch of yellow ochre. You can paint the houses similar to the way I did. Suggest the windows with the edge of your brush. Paint the roof tops on the left darker. They are in the mountain's shadow. Still using your No. 4 brush and the tree colors—but darker—paint the trees in front of the

Sky

Titanium white
Cobalt blue
Yellow ochre
Alizarin crimson

Shadow areas

Cobalt blue
Yellow ochre
Viridian
Titanium white

Sunlit areas

Yellow ochre
Viridian
Alizarin crimson
Titanium white

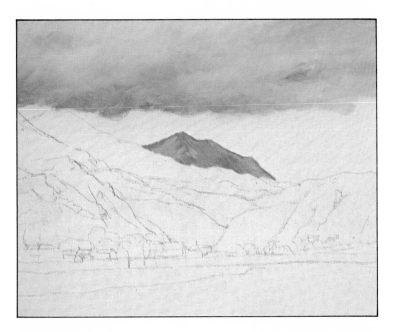

First stage

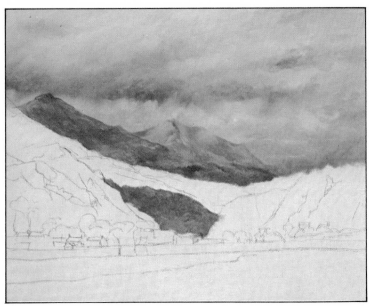

Second stage

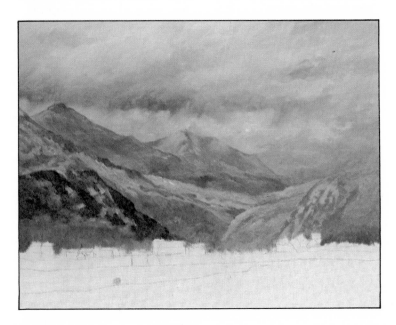

Third stage

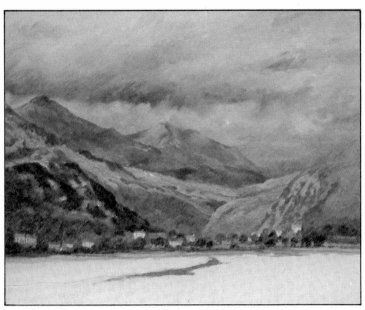

Fourth stage

houses. Paint the farthest field you can see in the middle with white, yellow ochre and viridian. Continue painting the trees over the top of this field. Mix a dark color with cobalt blue, alizarin crimson and yellow ochre. With the same brush, start at the left of the village and drag the brush horizontally under and slightly into the trees and houses you have painted. This gives a visual base for the village. It also creates that misty area in a painting where a lot is happening, but you can't show definition or details. This paint will mix with the wet paint of the houses and trees to help create the effect. With a clean No. 4 brush, paint the green field across the picture. Use horizontal strokes and a mix of viridian, yellow ochre and white. Paint the path leading to the village with the same colors.

Final Stage—With your No. 6 sable brush, put in the three trees at the front of the green field. With your No. 4 brush, paint the wall across the front of that field. Add the wall behind that one on the right of the picture. Use cobalt blue, alizarin crimson and yellow ochre for these walls. Paint the middle fields next. Use your No. 8 bristle brush and a mix of white, yellow ochre, alizarin crimson and a touch of viridian. Now paint the area in shadow, using cobalt blue, alizarin crimson, yellow ochre and a touch of white. Paint the path with the same colors, but lighter. If you want to alter parts of the painting, wipe the paint off with a clean rag. Wait for the paint to dry, and paint over the top.

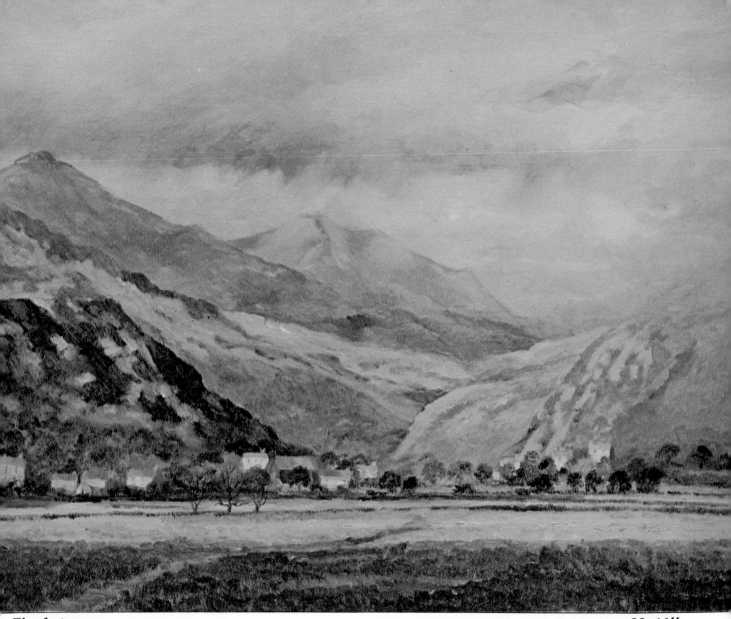

Final stage **20x16″**

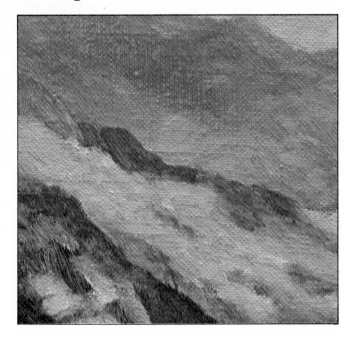

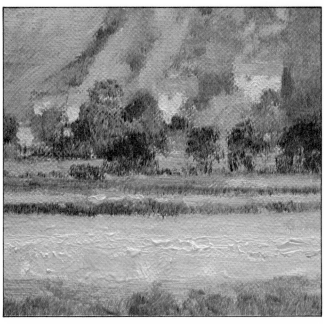

Painting the Sky in Oils

I believe an evening sky excites most landscape artists. Unfortunately, a strong, full-colored sunset is often too dramatized and overdone. I have concluded that some of nature's most startling effects can't be reproduced as paintings. They look unreal. But if we see them in nature, we accept and admire them.

For this sky exercise, I have selected a gentle sunset. I painted this on canvas in one sitting and used a gel medium to speed the drying.

First Stage—Draw the main cloud areas with your HB pencil. Use your No. 10 bristle brush and a mix of cobalt blue, white and a little cadmium red to paint the blue sky. Clean your brush in turpentine. Mix white, cadmium yellow, and cadmium red for the sunlit clouds. Add more cadmium red as you near the horizon.

Second Stage—Now put in cloud formations, starting at the top. Mix cobalt blue, yellow ochre, cadmium red and white. Use your No. 10 bristle brush. Work the brushstrokes out on both sides from the center. Let the brushstrokes follow the cloud shapes. Work the clouds over the blue sky. As you near the yellow sunlit sky, add more cadmium yellow and cadmium red to make the clouds pinker. Using the same colors with more white, paint horizontal clouds over the yellow-pink sky. Be gentle with your brush. You are going over wet paint.

Final Stage—Use your No. 6 bristle brush to high-light the clouds. Start at the top where they are whiter. Use white and cadmium yellow. When you get to the yellow part of the sky, add a little cadmium red to make it more orange. Use thicker paint. Add these highlights to the edges of the clouds. Now paint the house and tree silhouettes. They will give scale to the sky. Use your No. 6 bristle brush and cobalt blue, cadmium red and yellow ochre. Paint this area dark. Add more yellow ochre and cadmium red under the large break in the clouds. Add chimneys and television antennas with your No. 6 sable brush.

First stage

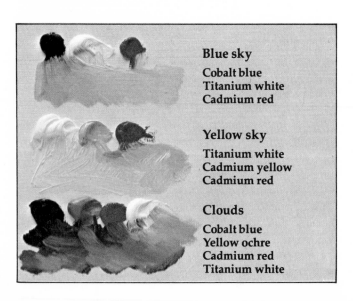

Blue sky

Cobalt blue
Titanium white
Cadmium red

Yellow sky

Titanium white
Cadmium yellow
Cadmium red

Clouds

Cobalt blue
Yellow ochre
Cadmium red
Titanium white

Second stage

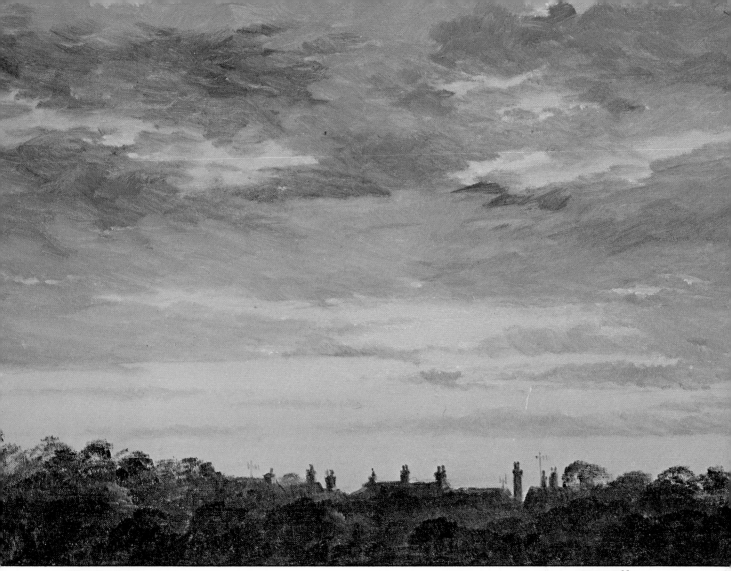

Final stage **16x12''**

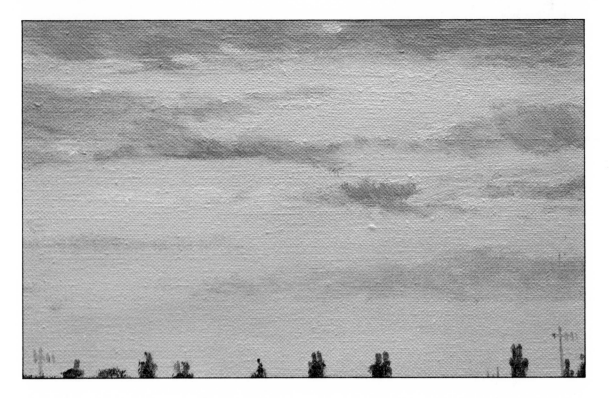

Painting Snow in Acrylics

This snow scene was painted from memory on acrylic-primed canvas. It is late afternoon. The sun is low and casts a glow over the snow.

First Stage—Draw the main features with your HB pencil. Use your No. 12 nylon brush and a mix of cerulean blue, crimson and white. Start at the top and work down. Add more crimson and cadmium yellow to the colors. Go over the horizon down to the foreground tree. Using the same colors, but hardly any white, and your No. 2 nylon brush, paint the distant trees and hedges. Then, with the same brush and plenty of white, paint the first snow-covered fields.

Second Stage—Paint the hedges and snow fields the same way to the two middle-distance trees. Paint these trees with your No. 4 nylon brush and a dry-brush technique. Don't put in any details. Paint the hedge by the trees with the same brush and technique. Use ultramarine, crimson and raw umber. Texture the trunks of the elm trees. Use your No. 4 nylon brush to paint the right tree first. Paint up to the small branches with a mix of raw umber, bright green, crimson and a little white. Then paint the small top branches with your No. 6 sable brush, using cadmium yellow, crimson, raw umber and white. Paint the branches in the direction they grow. Now paint the left tree with your No. 4 nylon brush and the same colors as the other. When the branches are too thin for the No. 4 nylon brush, use your No. 6 sable brush.

Final Stage—Continue with the small branches of the left tree. Use more water so your paint will flow better. Add a little ultramarine to your color mix. Change to your No. 6 nylon brush. Use the drybrush technique and the tree colors. Drag the brush down over the small branches you have painted on the left tree. Paint in the feathery branches, as shown on the opposite page. Paint the field in front of the two trees with your No. 4 nylon brush. Paint over the

First stage

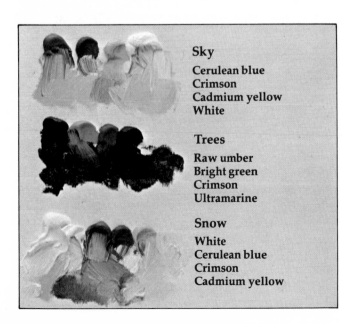

Sky

Cerulean blue
Crimson
Cadmium yellow
White

Trees

Raw umber
Bright green
Crimson
Ultramarine

Snow

White
Cerulean blue
Crimson
Cadmium yellow

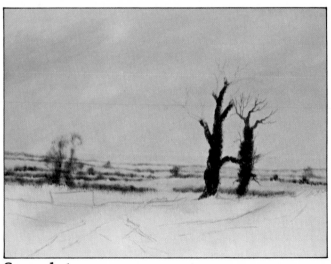

Second stage

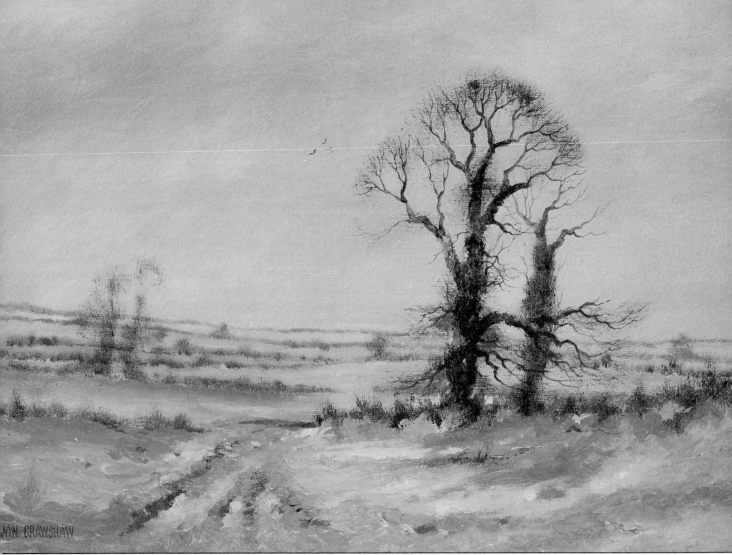

Final stage

16x12"

drawing of the gate. I left it out because I liked the picture without it. The colors for the snow are white, cerulean blue, crimson and cadmium yellow. Paint the hedge on both sides of the path, using your No. 4 nylon brush in upward strokes and a mix of cadmium yellow, crimson, raw umber and bright green. The foreground snow is next. It is difficult to explain each brushstroke, but I will explain roughly how I painted the snow. Do it the same way, but don't copy. Start with your No. 4 nylon brush. Paint the earth on the path and field with cadmium yellow and crimson. Work in the snow using snow colors. I added texture paste to the paint to give the snow texture. Work in a low key, as I explained in the section on ground and snow. Put in highlights and darks when your foreground is dry. Paint your path in perspective, letting your brushstrokes follow the direction of the path. Add details you think necessary to the trees with your No. 1 sable brush. Add highlights to the tree trunk and branches using bright green, cadmium yellow, crimson and white. Put in the birds' nests and birds with your No. 6 sable brush and a mix of burnt umber and ultramarine.

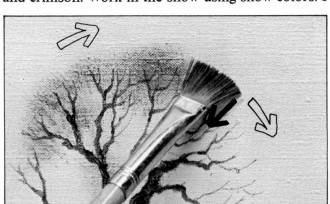

Painting a Meadow in Pastels

I did this pastel painting on paper from an outdoor sketch of Send Church. In the last stage, I changed the foreground field to a slight hill. This gave the picture strength, especially with the heavy shadow on the field.

First Stage—Draw the main features with your HB pencil. Paint the blue sky with the broad edge of the pastel and cerulean blue. Change to cobalt blue about two-thirds of the way down. Work back into the first color. Then carry it to the horizon. Now use the broad edge of raw umber. Paint the light clouds from the top down. Work them freely over the blue sky to the horizon. Work over the blue sky with cool gray. Put in the dark clouds. For the distant trees use green-gray. Use olive green for the field underneath, working back into the trees. Now paint the field under that, using sap green.

Second Stage—Paint the trees behind and to the left of the church with purple-gray. With sap green, work the two trees at far left, over the background trees you have just done. For the shadow side of the church, paint with cool gray. Then paint over it with burnt umber. Use burnt sienna for the sunlit side. Next paint the dark trees left and right of the church. Use green-gray. Add olive green in places over the top to change tones. Start using cobalt blue just before the large trees to the right center. Continue over this layer of pastel to finish the line of trees. Paint the two rooftops with cadmium red. Smudge them with your finger.

Final Stage—Paint the sunlit field using yellow ochre. Work it into the bottom of the row of dark trees. Paint the water with cobalt blue. Shape the shadow line of the bank with the end of a cool gray pastel. Use sap green for the field left of the bank. Use olive green for the bank. With broad, free strokes and sap green, paint the foreground field. Add gray-green over this to deepen the shadow area. Use pressure on the pastels to work the foreground. Draw the fence with gray-green. Highlight or darken where you think necessary.

First stage

Second stage

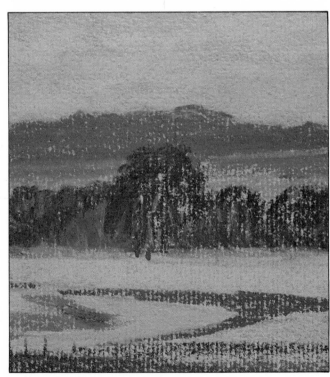

Final stage 15x10''

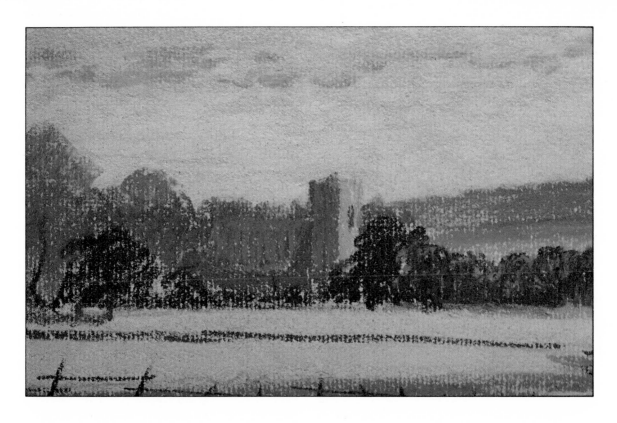

Painting Farm Buildings in Watercolors

This landscape was painted from a pencil sketch I did of a farm. When I did the sketch the same size as this watercolor, I had no idea I would use it later for a finished painting. But I had an urge to paint it in watercolors as an exercise for this book. I am pleased with the result.

First Stage—I used 140-pound, cold-pressed watercolor paper. Sponge the sky area with water down into the trees, but not over the roofs. While the paper is very damp, use your No. 10 sable brush to paint the sky. Use Payne's gray and a touch of alizarin crimson. Halfway down the sky, add yellow ochre to your wash. Work down to the right of the barn.

Second Stage—While the sky is damp, use the same colors and your No. 6 sable brush to paint trees on the background hill. Notice how this runs into the

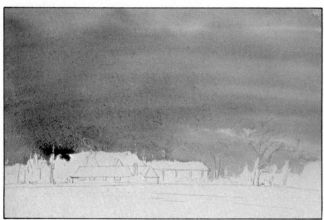

First stage

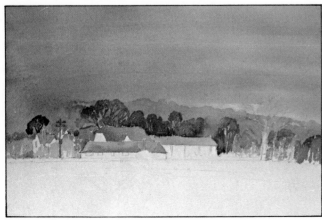

Second stage

sky left of the buildings. This is a *controlled accident.* When this is almost dry, paint the dark trees behind the buildings in the same colors, but darker. Draw these with the brush to give individual shapes. Drag the brush behind the larger tree on the right. Use the drybrush technique behind the tree to show watery sunlight on middle-distance trees. Paint the trees left of the buildings and behind the telegraph pole. Add more water and yellow ochre. With a wash of alizarin crimson and cadmium yellow pale and your No. 6 sable brush, paint the roof of the extreme left house and window. Put in the telegraph pole with the same brush, using your tree colors. Now paint the roof of the barn behind the house. Use a strong mix of alizarin crimson and cadmium yellow pale. Add some tree colors to this mix to make the house roof look weathered. Mix ultramarine, alizarin crimson and a touch of yellow ochre for the barn's gray roof. While you work on these stages you will find areas of color left on your palette. Don't wash them off. Use them throughout your painting.

Final Stage—With your No. 6 sable brush, use a watery wash of raw umber and Payne's gray on the end of the barn. Leave white paper between each brushstroke to represent highlights on the timber edges. Mix Payne's gray, alizarin crimson and yellow ochre for the inside of the barn. Leave white paper to represent support posts. Add more yellow ochre as you come to the bottom. Work this color out and right of the barn. Put another wash over the roofs with the roof colors. Don't do this on sunlit areas. Paint the large tree next, using your No. 6 sable brush and a wash of Payne's gray and burnt

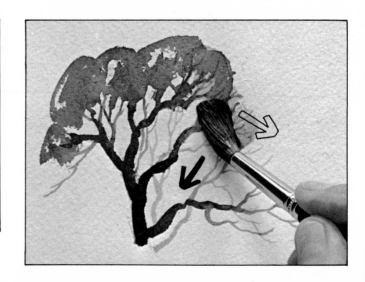

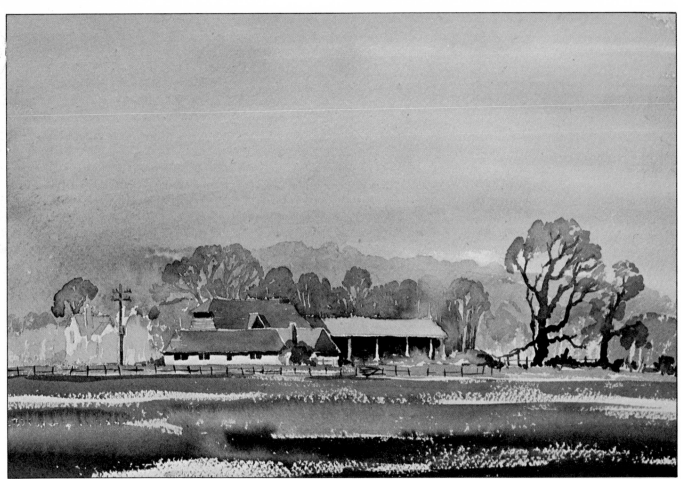

Final stage

16x10-1/2″

umber. Work the brush up the tree. Paint the main branches. Also paint the tree to the right of this. Put in the fence under the tree with the same color. While the two trees are wet, put in the feathery branches with the same colors. Let the wash run into the wet branches. Using the same colors—but darker—paint again under the barn. Do not paint to the bottom this time. Paint halfway down the white support posts. Use a mix of ultramarine blue, alizarin crimson and a touch of cadmium yellow pale to paint the window and shadows on the house and barn. Now paint the green field across the picture in front of the buildings. Use your No. 6 sable brush and a mix of Hooker's green No. 1, alizarin crimson and yellow ochre. Paint the plowed field in the foreground with your No. 10 sable brush. Use a wash of cadmium yellow pale, alizarin crimson and burnt umber and a touch of Payne's gray. Use plenty of paint. Paint freely. Leave white paper showing to give life. Add a touch of Hooker's green No. 1 with your No. 6 sable brush near the foreground. Put in the fence and any accents you think are necessary.

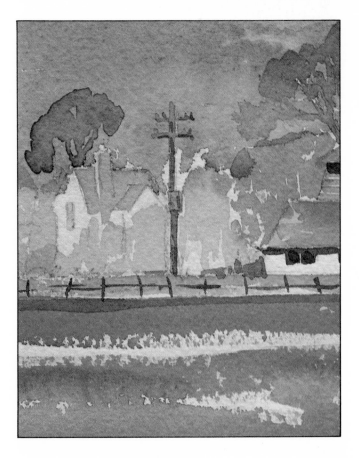

Points to Remember

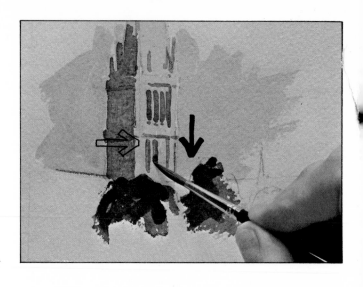

- Keep details to a minimum while you are learning.
- Paint plants, shrubs and trees in the direction of growth.
- Put something in your painting to denote scale.
- Always paint water to appear horizontal.
- Pay close attention to the sky. It conveys the mood of the landscape.
- Buy the best materials you can afford.
- Don't use acrylic paint over oil paint.
- Vary the color amounts in your mixtures.
- Use photographs as painting aids.
- Learn to observe. It is the key to good painting.
- Practice painting one step at a time. Master the basics before you advance!

Index

A
Acrylics, 12, 14, 15, 38, 48, 58
Atmosphere sketch, 8, 20, 30, 36

B
Bird's-eye-view, 16
Bristle brushes, 14
Brush case, 12
Brushes, 12

C
Camera, 30
Canvas, 12
Canvas board, 12
Charcoal, 12
Clear fixative, 12
Clouds, 20
Constable, John, 4, 30
Crawshaw, Alwyn, 4

D
Dark, 6
Daylight, 6
Depth, 17
Designer's gouache, 14
Dimension, 17
Doodles, 18
Drawing, 8, 16
Drying medium, 12
Dusting brush, 12

E
Enjoyment sketch, 8
Equipment, 12, 14, 15

Equipment carrier, 42, 43
Eye level, 16

F
Family photos, 28
Farm buildings, 62
Fixative, 12
Form, 17
Frame, 36

G
Grades of pencils, 35
Ground, 20, 26

H
Hog-bristle brushes, 14
Horizon, 16

I
Impasto medium, 12
India ink, 12
Information sketch, 8, 22, 26, 30, 36, 42, 44
Ink, 12

J
Jar, 12

K
Kneaded eraser, 12

L
Landscapes, 6, 7, 12, 20, 26, 56, 62
Linseed oil, 12

M
Materials, 14
Meadow, 60
Mediums, 12
Memory, 28
Mist, 6
Mixing colors, 18
Mixing knife, 12
Mood, 20, 28
Mountains, 521

N
Normal view, 16
Nylon brushes, 14

O
Observation, 26
Oils, 12, 14, 15, 56
Opaque-watercolor painting, 43
Outdoor sketching, 10
Ox-hair brushes, 14

P
Paint rag, 12
Paintbox, 12
Painting, 18
Painting a watercolor on location, 44
Painting knife, 12
Palette, 12
Palette knives, 12
Pans, 12
Paper, 12
Pastels, 12, 14, 15, 60

Pen, 12
Pen-and-ink, 44
Pen-and-wash drawing, 43
Pencil sketch, 38
Pencil sketching on location, 34
Pencil sketching outdoors, 36
Pencils, 12, 35
Perspective, 16, 17
Photographs, 30
Primary colors, 18
Primer, 12

R
Rain, 6
Reflections, 24

S
Sable brushes, 14
Scale, 9, 26
Senses, 6, 7
Sharpening a pencil, 34, 35
Sketchbook, 8, 12, 36
Sketching, 8, 10, 30, 34, 35, 36, 38, 42, 44, 48
Sky, 20, 21, 56
Snow, 20, 26, 58
Specific sketch, 8
Sponge, 12
Squirrel-hair brushes, 14

Sun, 6
Sunrise, 6
Sunset, 6

T
Texture paste, 12
Three-dimensional form, 16
Tints, 12
Tissue paper, 12
Tone, 26, 27, 35
Trees, 20, 22, 23
Tube paint, 12
Turner, 30
Turpentine, 12

V
Vanishing point, 16
Varnish, 12

W
Water, 20, 24, 25
Water containers, 12
Watercolor sketch, 48
Watercolor sketching outdoors, 42
Watercolor wash, 25
Watercolors, 12, 14, 15, 44, 62
Wet-on-wet, 21
White designer's gouache, 12
Wind, 6
Workable fixative, 12
Worm's-eye-view, 16

7.3265498642